ON BEING 100

31 Centenarians

Share Their

Extraordinary Lives

and Wisdom

LIANE ENKELIS

PRIMA PUBLISHING

3000 Lava Ridge Court · Roseville, California 95661

(800) 632-8676 · www.primalifestyles.com

PRIMA PUBLISHING and colophon are trademarks of Prima Communications Inc., registered with the United States Patent and Trademark Office.

Library of Congress Cataloging-in-Publication Data on File
ISBN 0-7615-2828-8

00 01 02 03 NN 10 9 8 7 6 5 4 3 2 1
Printed in the United States of America

HOW TO ORDER

Single copies may be ordered from Prima Publishing, 3000 Lava Ridge Court, Roseville, CA 95661; telephone (800) 632-8676 ext. 4444. Quantity discounts are also available. On your letterhead, include information concerning the intended use of the books and the number of books you wish to purchase.

Visit us online at www.primalifestyles.com

To Richard, thanks for being there—always

CONTENTS

INTRODUCTION

WHAT IS IT like to be one hundred? How can I live to be one hundred? What can I learn from one-hundred-year-olds about living a fulfilling life? These are some of the questions I asked myself when I started this project of portraits and interviews in 1998, the year I turned fifty. I found it fascinating to meet people twice my age, and I found a few answers, too.

This book will not tell you the secret of longevity because there doesn't seem to be one. Even medical doctors doing intensive studies of centenarians agree that there is no one factor that contributes to longevity. Heredity plays a role, as do a person's health habits and environment. Floyd Schmoe was correct when he jokingly advised, "be very careful in the selection of your ancestors."

However, one of the advantages that this featured group of centenarians has over future generations of centenarians has nothing to do with medical science; it has to do with timing. They all grew up before cars and television dominated our lifestyle. These people were not couch-potatoes in their youth. Like Emma Wright, they really did "walk a mile to school"—or more. And for most of them, walking continues to be a form of exercise.

Additionally, there are some common personality traits among these thirty-one centenarians, which may well contribute to their longevity. All of them are independent and strong-willed. Many of their family members describe them as determined, single-minded, or stubborn.

Many, like Jose Flores, stress that happiness comes from living the simple life. And like Jose, their lives were not so simple—even the lives of farmers and homemakers were filled with complications. Because of the lack of modern medicine, it could not be taken for granted that children would survive to adulthood or that women would survive childbirth. Although we like to think fondly of the early part of the century as having been a simpler time,

without the hustle and bustle brought on by technology, it was an era of hard work and hardships.

It takes strength of character to live to be one hundred in a century like this one just past. Many of the stories shared in this book pay tribute to the ability of the human spirit to triumph over prejudice and hatred. Pepi Deutsch survived the Holocaust. Parker Yia-som McKenzie tells of his experience in government-run Indian boarding schools. Asako Kudo relates her experiences in an internment camp for Japanese-Americans in Arizona. Samuel Wilson, Herbert Young, Hortense Ridley Tate, and Louise Scott all tell stories of battling segregation. Bernard Karasick tells of fleeing pre-Soviet Russia. Frank Orsi, along with Samuel, Bernard, Herbert, and Homer Fisher tell of horrific trench warfare in the First World War, while Floyd tells what it was like trying to rescue the wounded. There were many times that the stories shared by these centenarians moved me to tears. Yet, despite this bleak sounding litany of events, *On Being 100* is a celebration of life.

A positive, optimistic attitude is shared by this group. Bobbie Green expresses this outlook most succinctly: "I am happy because I choose to be." Although they readily admit frustration with some of the consequences of advanced age—loss of mobility, loss of eye sight, loss of hearing—they have adapted. The hardest adjustment is loss of friends and family. All have outlived their spouses and many have also outlived their children. The attention of grandchildren and extended family and friends is cherished.

These centenarians also share a sense of adventure and wonder—a pioneering spirit. Esther Burney, Clara Shaver, and Audrey Stubbart were pioneers, living on the frontier. Frank Orsi, Bernard Karasick, Asako Kudo, Hazel Wolf, Jose Flores, Herbert Young, Theodore Young, and Macedonia Cenatiempo left their homelands. Others embraced new technologies. Herbert Young, Walter Keller, and Milton Garland were all fascinated with automobiles, engines, and electricity. Milton Garland and Theodore Young became pilots.

Coupled with this sense of adventure is a love of learning and a willingness to embrace new ideas and beliefs. Several changed religious affiliation in mid-life. Others re-examined long held stereotypes. Hazel came to accept gays and lesbians as friends. Faith Guthrie, the granddaughter of a Confederate soldier, came to accept blacks as equals.

Many stress the importance of having a purpose, of making a difference. They continue to desire to contribute to society. Floyd, Hazel, and Hortense have continually fought for human rights. Clara has devoted her life to saving souls. Ruth Hamilton, who became a state legislator, urges, "If you believe

in something, stick with it. I just wish I could live to be one-thousand-years-old because there are so many things that I want to see improved." Lucille Diamond sums it up, stating directly, "It is very important to help other people."

Walter Keller, Milton Garland, Audrey Stubbart, and Faith Guthrie still go to work. "I have to have something valuable to do," Audrey states emphatically. Hortense still tutors students. "I'm glad to be active and of service," Hortense says, adding, "I feel so keenly that I must continue on, because what I do will speak for tomorrow; and then tomorrow will take care of itself because of what we have done today. I want the world to be better, and I want to have a part in making it so." Floyd concludes: "I've always believed that individuals are responsible for what happens in this world, that we can make a difference."

On Being 100 is like turning the pages in your grandmother's old family photo album or reminiscing with your great uncle about a time when cars were new and airplanes uncommon. The shared memories and insights here give a personal view of the past century's events—truly an experience of our living history. Thanks to fate of timing, many of these centenarians lived in three centuries and remember most of the twentieth century. Many of these thirty-one centenarians were selected because they lived through some of the major historic events of the early twentieth century. The work of others helped shape the century. Frederica Maas wrote silent films. Theodore Young worked on the design of the Jefferson Memorial. Janet Lewis won a Guggenheim Fellowship for her poetry and novels. Hazel Wolf founded more than twenty Audubon Society chapters. Parker Yia-som McKenzie developed a method for writing his native Kiowa language. Hortense Ridley Tate was a co-founder of the National Council of Negro Women, along with Mary McLeod Bethune in 1935. Milton Garland holds more than forty patents in the area of refrigeration. Floyd Schmoe has been nominated three times for the Nobel Peace Prize. While these are ordinary people, not famous celebrities, they did live extraordinary lives.

Although every effort was made to present a diversity of stories, with only thirty-one people it is impossible to represent every national heritage, ethnic background, religious belief, etc. Rather than concentrate on the differences, it is interesting to see the similarities in perspectives presented.

I was also struck by the similarities between their generation and mine. Like these centenarians, baby-boomers, whether or not they were "flower children" in the 1960s, have a strong desire to make a difference in the world. The more I heard about the roaring '20s, the more I realized that the psy-

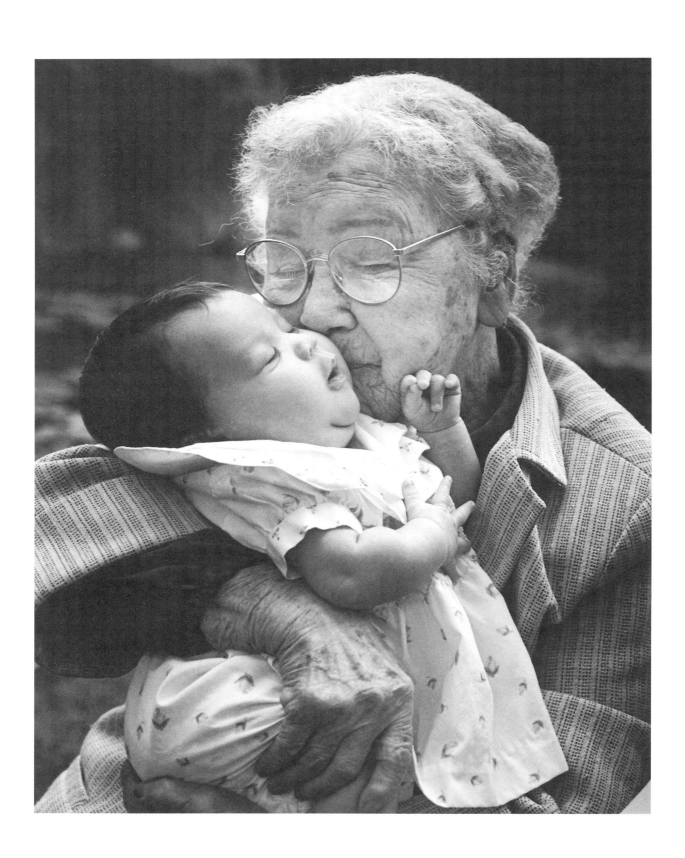

Asako Kudo

BORN MAY 25, 1898

Japanese Picture Bride—Born in Fukuoka, Japan, Asako Kudo emigrated to California in 1916 as one of the many young "picture brides"—wives chosen by Japanese men living abroad on the basis of photos and letters.

She traveled across the Pacific Ocean in 1916 to marry a man she had never met.

"My older sister was married and living in California already. My future husband was farming for her husband near Los Angeles. My sister showed him my picture and asked if he would like me as his bride," Asako explains. "Since he agreed, she sent me his picture and wrote, 'If you like what you see, come right away. But if you don't like him, let me know right away that you want to call it off.' Since my family in Japan was very poor and I wanted to have a better life, I decided to go to America and become his wife."

No letters were exchanged between Asako and her husband-to-be. With just the recommendation of her sister and hopes for building a better life, eighteen-year-old Asako accepted her sister's money for passage to America on the ship *Tenyo Maru*. Two weeks later the ocean liner docked in San Francisco and Asako began her new life.

"My future husband, Otohiko Kudo, came from Los Angeles by train to meet me. He told me years later that when he looked at my picture, which

he was holding, and then looked at me that night he thought, 'Something is very different, but she's okay.' When I saw him for the first time, I thought, 'Well, I guess he is all right; he will do.' So we got married that night and took the train back to Los Angeles."

When asked if it was a good marriage, Asako looks quizzically around at her daughter, son-in-law, and two of her sons who are translating the conversation for her—all of whom are now more than sixty-five years old. It seems as if she is asking, "Do you expect me to discuss my marriage in front of the children?" She then replies frankly, "We were married sixty-seven years. He died in 1983. How would you define good? We fought like any couple, but we were happy, too."

This frank, no-nonsense outlook is the cornerstone of Asako's personality and has sustained her through many hardships. Throughout the Depression and the internment camps of World War II, Asako's positive, down-to-earth approach to life provided strength and stability to her family. The couple raised six children, five boys and a girl. She now has seventeen grandchildren, thirteen great-grandchildren, and three great-great-grandchildren, and all four generations revere and adore their family matriarch.

Family bonds were important right from the beginning of the Kudos' marriage. Asako's sister and brother-in-law welcomed the newlyweds and gave them jobs. "We worked on the commercial flower farm owned by my older sister and her husband in the Los Angeles area, near what is now Buena Park. Their family name was Iwata. About a year later, we leased an adjacent field and started a farm of our own—chrysanthemums and other commercial flowers. Business was good enough that we moved to El Centro, and my husband and I farmed one hundred acres," Asako says proudly. "We worked hard. We became wealthy enough that we even owned two cars."

Soon Asako found joy in motherhood. "Our first son, George, was born when I was twenty. *Jichan,* Papa, as we called Otohiko, only knew three American names for boys: George (Washington), Thomas (Jefferson), and Benjamin (Franklin)," she explains. "So our last two sons were given Japanese names, *Shiro* for fourth son and *Goro* for fifth son. We wanted a baby girl for so long. When she came, we called her *Yudiko,* Lily."

Unfortunately, the family's fortunes soon changed. "In 1929, we had our one hundred acres planted in cantaloupe. We shipped the entire harvest to New York. Not one nickel came back. That was how the Depression came to us," Asako says with resignation. "We had to sell everything. We rented a big truck and packed up all our belongings and went back to work for the Iwatas."

With hard work, the Kudo family began to prosper again. "Even in the Depression, the commercial flower business was pretty good," Asako recalls. "Soon, we went to Lindsay, California, where Jichan had a friend named Yueda, who encouraged us to come up there and farm. We sharecropped, mostly cantaloupes, for a number of years."

Just as life was starting to go well for the family, history dealt them another tough hand, which they played through with grace and dignity, but there were no winning cards. When the Japanese bombed Pearl Harbor, thus bringing the U.S. into World War II, all people of Japanese descent living on the West Coast were relocated to detention camps. Recalling this era stirs up painful memories for Asako, and she wipes away tears as she speaks.

"When the War broke out in 1942, we had twenty acres of tomatoes ready to be picked in three days. We were told to move out right away, immediately. We lost everything—the whole crop, the house Jichan had built, the car, the truck, farming equipment, our furniture. We had to leave almost everything we had. We could take only some clothes, books, and pictures. He was so angry," she says, her voice quivering.

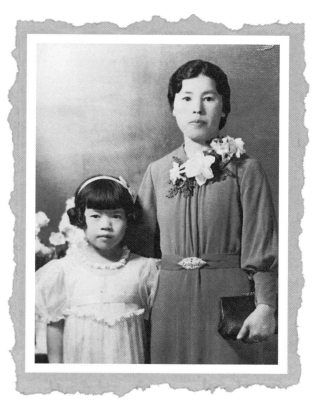

Asako with daughter Lily, 1934

"We were in camp at Poston, Arizona, for three days. When we got there, rifles were pointed at us, but we couldn't understand why. It was dismal and windy. Sand was always blowing. We knew of no other home except California. Now we were in a place that was very strange to us. There were rows of barracks, no better built than chicken coops. Each barracks was divided to hold four families, one fifteen-foot-by-twenty-foot area for each family. All of us, our whole family, had only that small space. We were given bags to fill with straw for mattresses. We had folding cots, but no other furniture. Jichan later built some out of scrap wood. Water and toilets were in another building."

The camp residents were soon put to work making camouflage nets for the war effort, and were paid only ten cents an hour. The residents were also responsible for their own food preparation and well-being. Soon, a community spirit took hold. "No matter what, things are never as bad as they appear," Asako states. "We did find things to laugh at during our time at

camp, and we made friends with other families. At least we were all together; we all survived."

"What kept me going, more than anything, was that I was just trying to raise my family, day by day," Asako says softly.

Her children recall her fierce determination to protect and preserve their family unit during that intolerable time. Her daughter, Lily, says, "Our mom, *Bachan,* always has a positive outlook. Despite her lack of formal education, Bachan has the wisdom to be able to see the best in everyone, no matter what the situation. She has a wonderful sense of humor that endears her to everyone. She makes you smile." This positive spirit not only sustained Asako during the hard times, but probably has contributed to her longevity.

"No matter what, things are never as bad as they appear."

Asako recalls that life in the camp took on a routine. "The camp became a self-supporting city of two thousand. We had our own schools, fire department, police department, and our own leaders. People started doing the work they knew—teachers, machinists, mechanics, farmers. There was a communal mess hall where we had to cook our meals. All the women would get together to cut vegetables and prepare everything, and this is where I worked.

"We got permission to farm outside the camp and we grew our own vegetables. We built reservoirs to collect water and built dikes and irrigation ditches. So many of our boys were in the Army that we didn't have enough farmhands. So, we recruited the neighboring Indians and taught them farming. After the camp closed, they took over the farm and became farmers."

Feeling angry and betrayed, Otohiko Kudo was ready to move his family back to his homeland; his sons took a different path. "The government questioned our loyalty, then recruited our sons for military service," Asako recalls. "Benjamin volunteered first. It broke my husband's heart. In the end, the boys saw that they had no place in Japan; they were born in America—they are Americans—so they enlisted."

The end of the war resolved little for the Kudos. "We had no place to go, no farm, nothing," Asako states. "Jichan didn't have the will to start over. He felt he had enough bad luck for one man. After the war, we all worked on other people's farms. Eventually, we had enough money for George to put a down payment on ten acres. Jichan taught George flower farming. My husband and I lived with George's family until Jichan had a stroke and died. George now has a seventy-acre flower farm that he works with his sons."

Looking at this spry centenarian, you do not sense all she has been

through. She walks briskly and there is still a spring in her step. Her cane seems more for show than for balance. Although her hair is white and she wears hearing aids and glasses, her whole face crinkles with childlike glee when she holds her newest great-great-granddaughter, the baby born one hundred years after her own birth.

This newest family member inherits a legacy of tradition. Asako has been diligent in teaching her children her heritage, and they continue customs and celebrations from Japan, which they weave smoothly into modern American life. For instance, the New Year's harvest festival of rice pounding, *mochi-tsuki,* has become the time for the annual family reunion. Everyone gets involved and more than two hundred pounds of rice are steamed and made into balls. Each family takes home a special treat.

Although traditions are the backbone of Asako's life, she is still up to learning new things. In 1999, at age 101, Asako finally became a U.S. citizen. "I never learned to speak English, but I understand a little bit," she explains. "I did learn some Spanish during all my years of farming." Nonetheless, with tutoring and help from family as translators, she passed her exam and proudly took her oath.

In looking back on all her experiences, she reflects, "Women coming from Japan to the United States when I did were brought up not to make waves; we were taught to do as we were told. So, whatever happened, I accepted it. Going to the camp, leaving everything, what else could I do? Just so long as my children were with me, that was all that mattered. You cannot avoid your fate; you accept it and make the best of it."

Asako Kudo has certainly given her family an inspiring example of how to make the best of whatever life deals you.

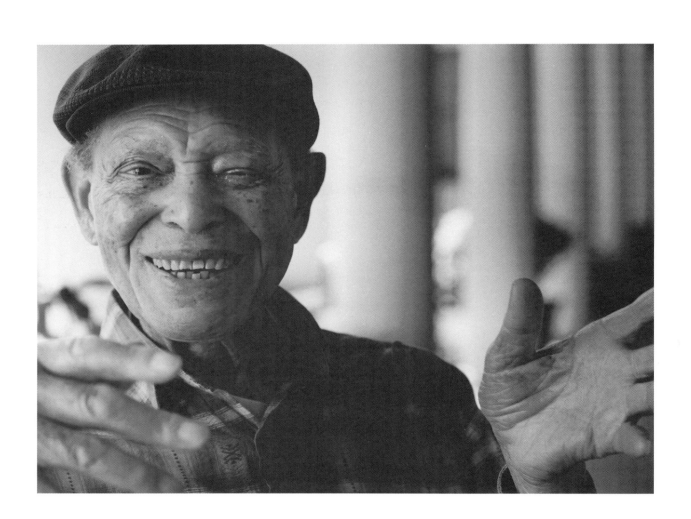

Samuel Wilson

BORN APRIL 30, 1899

World War I Veteran and Tradesman—The grandson of former slaves, Samuel was born and raised on a cotton farm in Strong, Arkansas, leaving home to serve in World War I. He stayed in the Army for nine years, traveling around the country. Eventually he settled in the West, where he found fewer problems with "Jim Crow" attitudes.

WHEN YOU FIRST meet him, it's hard to believe that Samuel Wilson is a centenarian. With his smooth, light brown complexion and bright smile, he could easily be mistaken for an octogenarian or even a septagenerian. But when he describes his childhood and tells his family history, he takes you back to another era, to a time that left a scar on our country as well as Sam's family history. The grandson of former slaves, Samuel Wilson grew up plowing the fields with a team of mules on a cotton farm in Arkansas. He left home to join the Army during World War I.

"My father raised cotton like his father before him. My mother's father also raised cotton. My grandfather on my mother's side had five boys and four girls and gave each one sixty acres of land," Sam recalls as he reflects on his grandfather's accomplishments. "He also had two sharecroppers who had been with him since slavery. My granddad had a lot of land and seven mules."

For that land and those mules, Sam's family had paid the steep price of generations of slavery. With a soft, Southern rhythm to his speech, Sam recalls the history of his family's farm, "When they turned the Negroes free, my

grandfather's boss told him, 'What's you goin' to do now? I don't want you to be workin' for me; you go out and make somethin' for yourself.' So he gave him land—that's what type of fellow he was. He started my grandfather out with a hundred and fifty acres and two mules and said, 'If you get any more, you get it yourself.' My grandfather ended up with six hundred acres of land. My grandfather's farm was about eight miles from the Arkansas-Louisiana line. My grandfather was a big fellow, about 230 pounds, and a strong farmer."

As he talks, Sam gestures animatedly, as if his family was gathered around and he's pointing out each member of the group. About his mother's family, Sam says, "My grandmother on my mother's side—my mother's mother—was a slave in Louisiana. She was a houselady so she didn't know nothin' about farm work; she just worked in the house. Her daughter, my mother, was a tall, slim woman who could shoot as good as a man."

Sam continues describing his heritage. "My mother's father was half Indian. His father—that's my grandfather's father—he was white. My father's mother was one of those mixed-types from Louisiana—Creole they call them—and she had become very rich, owned a big plantation." He concludes, with a throaty chuckle, "I guess that just makes me one ugly old mutt."

This rich heritage has been a source of strength for Sam, particularly during his childhood. Sam grew up surrounded by family—with his uncles, aunts, and grandparents owning farms adjacent to his father's. Their rural life was a quiet, almost protective, environment where everyone knew and got along with each other. Nostalgically, Sam says, "Life was simpler there. My family did all right in farming. We raised just about everything we ate."

He describes the area. "In the little town I was from, Strong, Arkansas, there was only about three large stores, but *anybody* could get about anything you wanted from cooking oil to suits. They had oil for your car—if you had one. Or grease for your wagon or wagon wheels. They even had tires for the wheels. We had three-and-one-half-inch tires on our wheels because they was larger and easier for the mules to pull—and we hauled a lot of stuff. Of course, there was only about three groups of families—all of them Negro—in that village of about forty miles square."

Sam only attended school until he was about ten years old, and then worked the farm with his father. He had a younger sister and a brother who died in infancy, so he was needed on the farm. Besides, school never held his interest. "I never did have time to go to school," Sam reflects with a bit of regret in his gravelly voice. "If I'd've got an education, I'd be better off today."

Family influences shaped Sam's life in another way, he says. "I had a

cousin I ran around with. We went into the Army together; it was his idea. I never would've gone in the Army if it hadn't been for him. I enlisted at St. Louis, Missouri, when I was sixteen—almost seventeen. I lied about my age."

The Army introduced Sam to a world that was very different from his small town. Although his unit, the Tenth Cavalry, fought in Europe during the war, Sam was not sent overseas.

He remembers, "I went all over the United States. A young person today wouldn't believe what it was like back when I was a kid. Everything was separate—segregated—though I never thought much about segregation until I went off to World War I. Then I was turned out of places in the East. I have never been 'Jim Crowed' in the West."

The Army gave Sam many new opportunities despite the racial prejudice he encountered. He recalls, "When I first went in, I was in the medical department as a doctor's assistant. Then the Army decided I was worth more to them in the engineers' corps.

"The best thing was all the experience. Working with the engineers was beneficial to me after I quit the Army. I was in almost nine years. When I came out of the Army in 1924, I was gettin' eighty-nine dollars a month. It could've been better, but it was all right."

Although the Army in those days did not provide black soldiers with any formal education or much opportunity for advancement, after leaving the Army, Sam put his military experience to use in the construction trades. First he went to work with a land developer in Kansas, then he worked his way across the country.

He summarizes his peripatetic career: "I liked construction real well. I could do most any type of construction—building roads, leveling land, and so forth. I can read blueprints. There was always good money. I would do so many things. I even worked on a ranch in Arizona—cattle, horses. I did all right in my own way. I never was out of a job.

"I never worked with someone I couldn't learn from. I mostly learned by watchin' what other people did. One day I was watchin' a guy doin' plaster. The next day I tried it and my boss said, 'If you can do that good, you should be a plasterer.' So he took me down to the union and signed me up. I went from makin' two dollars an hour to makin' eight."

Sam enjoyed his footloose life after the service. "I always had a car. I

"I went all over the United States. A young person today wouldn't believe what it was like back when I was a kid. Everything was separate—segregated."

had a little two-seater, a Dort. They quit making them more than seventy years ago, but it was sure a cute little thing," Sam says fondly of his coupe made by the Dort Motor Company of Flint, Michigan, which was only in business from 1915 to 1923. The car was a real piece of history, as Sam describes it. "It had one seat in front and one seat behind, and you could put a chair or stool next to each seat if you wanted to take on more people. Later, I had a big Pontiac—I liked big cars."

Sam enjoyed having nice clothes to go with his nice car. He describes himself as having been a very snappy dresser. After a hard work week, he liked to let loose. He was single most of his life, and says with a sly smile, "I was quite a ladies' man. I didn't drink much, but I sure liked to dance."

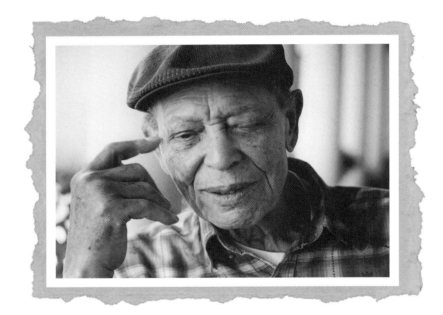

He won't say whether he left behind a string of broken hearts as he moved across the country. It was a woman in San Francisco who finally got him to settle down. "I didn't marry until 1960," Sam states. "I was going with a girl who said, 'Sam, don't you come around to see me no more. I'm through with you. I've been goin' with you three years and you ain't never said nothin' about gettin' married. You don't want a wife. I'm gettin' old, and I want a husband.' So I told her, 'I'm not goin' anyplace.' We were married twenty-two years until she passed."

After his wife died, Sam lived alone. But, his driving days ended when he was in his nineties, and his dancing feet now need a walker to help them navigate. The once-rambling man now lives a quieter life in a retirement community run by the California Department of Veterans Affairs. "I like to read everything I can get my hands on—books, newspapers; it don't make no difference," Sam says. "I read the Bible every day."

Sam is philosophical about his long life. "I'm not a bad fellow," he says sincerely. "Nobody can say that Samuel Wilson has done them an injustice. My grandmother always said, 'If you can't do something nice, at least do no harm.' I've tried to live by that.

"But I'm bullheaded," he admits. "When I was young, nobody could tell me nothin'. I've made a lot of mistakes, but," he adds with a grin, "I've sure had a lot of fun."

He shakes his head with resignation though, and adds, "But I was a fool. I quit on my education when I was ten. I thought I was pretty sharp; I would rather work. If I'd went to school, I'd be better off. That's really the one big mistake I made. You can never get enough education—anybody but me knew that."

"If I'd went to school, I'd be better off. That's really the one big mistake I made."

Pepi's early life had not been particularly affected by politics in the first decades of the century. She grew up in a peaceful village, with both Christian and Jewish friends, and spoke both Hungarian and Rumanian as a practical matter for doing business. She recalls a happy childhood. Her parents wanted her to have the best education they could provide, so sent her to school in a neighboring larger town through eighth grade.

Although she describes meeting her husband through "a formal introduction," a romance blossomed between them. Her face lights up when she speaks of her courtship with Josef. "We saw each other only at my father's house, only under supervision. But once we walked in the garden and held hands. And once when we waited for a coach, he kissed me." That she remembers these tender moments more than eighty years later attests to the love that grew between them. They were married November 3, 1919. They eventually had a son, Zoltan, and a daughter, Clara.

The couple moved to a larger town, with about seven hundred Jewish families and about the same numbers of Protestant and Catholic families. Josef, a shoemaker, opened his own business. "In those days, almost everyone wore custom-made shoes, but we did sell some ready-made shoes, too," Pepi explains. "I worked in the shop. Our customers were every type of person. There was no anti-Semitism.

"The anti-Semitism started in 1940 with restrictions on Jewish-owned businesses. The first restriction was that Jews were forbidden to employ non-Jewish workers." Pepi tells how this hurt their business: "My husband had twenty employees and only one was Jewish, so we couldn't keep nineteen of our employees. For two years, we struggled to support ourselves and keep the children in school. It was difficult to get leather, so he couldn't make many shoes either. He did repairs or anything he could to earn a living."

Pepi explains that no one expected what was to come. "Once a Polish man came to our little town and said, 'Something terrible is happening in Poland. People are being taken out of their houses and sent to ghettos.' And nobody believed him."

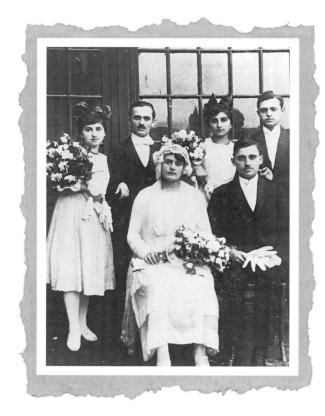

Pepi and Josef, wedding portrait, November 3, 1919

Pepi feels that the restriction on education was one of the worst placed on the Jews. "In 1942, Jews were not allowed in school, so we made a Jewish school."

"The teachers were fantastic," Clara interjects. "All the Jewish school teachers and university professors who were kicked out of the schools taught there." Mother and daughter frequently complete each other's thoughts, and Pepi concludes: "We felt we couldn't leave a whole generation uneducated," indicating that they still had hope for the future.

"There is one philosophy that Josef gave our children," Pepi recounts. "'What is in your head, they can't take away. That is why you have to study. We are people of books, we are people of law. Do not give up any opportunity to learn.'"

But, that hope began to fade when, in 1944, Jewish businesses were shut down. "We could not go anywhere; we had to just stay in our house. We could only go out between 10 A.M. and 2 P.M. We wore yellow stars and were isolated from everybody." Pepi shows her faith in the basic goodness of people, by adding, "Some people helped us by bringing us milk or food."

That fateful day in May 1944 is etched into Pepi's memory. She describes the soldiers' orders: "They told us to take some food and blankets. They said we would be working in factories to help the Germans win the war. Our homes would be used for housing soldiers."

The family was evacuated into a ghetto, which Pepi describes as "a vacant brick factory—a big, empty warehouse." Pepi describes it further: "They brought in Jews from many small towns. There were ten thousand people in the ghetto."

Pepi suffered an emotional wound the first day. "Every gold piece had already been handed in, but I had managed to keep my wedding ring. At the ghetto, the soldiers saw my ring and wanted it. I protested. I hadn't taken it off in the twenty-four years of my marriage. They laughed and said I wouldn't need it where I was going, and pulled my ring from my finger."

But she did not expect the physical hardship and abuse that was to come. The building was never intended to be used for housing. Pepi describes the conditions: "There were no toilets, so we had to dig latrines, trenches. Clara's boyfriend was one of those ordered to dig the latrines. He said no, that this was sub-human conditions. They hanged him and made my husband do it. They didn't know that

"At the ghetto, the soldiers saw my ring and wanted it. I protested. I hadn't taken it off in the twenty-four years of my marriage. They laughed and said I wouldn't need it where I was going, and pulled my ring from my finger."

there was a relationship between them; it was just how it happened," Pepi sighs, overcome with the flood of memories. Clara continues, "Fortunately, he didn't die then. They cut him down as soon as he passed out. The soldiers just wanted to set an example and scare us so that no one would refuse to work."

Pepi describes their feeling of helplessness. "Day-to-day it was a terror—beatings, hangings, shootings. My husband cried at night. He kept asking, 'What did I do? Why does this happen to us?' He was only forty-six years old. He was afraid that we would not survive. Our only hope was that somehow we would all stay together—that we could keep our family safe."

Pepi's extended family was in the ghetto. She describes the family's will to survive. "My husband's brother, who had married my sister, wanted to have his family all commit suicide—himself, his wife and two children. He brought poison with him because he foresaw something terrible was going to happen. Our whole family got together, all thirty-seven members, and they said, 'No, you can't do that. We are all together; we must support each other. As long as the family is still together, we don't have to worry.' My mother and my mother-in-law begged him. So he did not. But nobody of his family came back; they all died in Auschwitz."

After four weeks in the ghetto, everyone was told to pack their clothes and food for three days. "They had given us no food there, so what did we have after the four weeks?" Pepi just shakes her head, no longer trying to understand the past horrors. Everyone was packed into cattle cars, seventy people to a car, and locked in. They were on the train for five days. "We could not lie down; we could only stand." Pepi describes the worst indignity: "We had a pot in the corner to use as a toilet, which was only emptied once."

The train arrived at Birkenau, near Auschwitz, at night, Pepi remembers. "I immediately knew there was a crematorium. I smelled the flesh burning. But, I thought that was the way they disposed of the bodies of workers who had died, or maybe were killed by the guards. I never could have imagined the whole truth."

Immediately upon arrival at the camp, the men and women were separated. "That was the last time I saw my son and husband," Pepi says. "All the other mothers were off on one side, but Clara wanted me to stay with her. It was lucky that I stayed with Clara because most women my age were sent to the gas chamber, considered too old to work."

"That was the last time I saw my son and husband. . . . All the other mothers were off on one side, but Clara wanted me to stay with her. It was lucky that I stayed with Clara because most women my age were sent to the gas chamber, considered too old to work."

Pepi describes the conditions at Birkenau. "We were two thousand women and teenage girls in an empty barracks, not even bunks or blankets. The food was warm, brown water and hard bread once a day. Clara and I were lucky because we only lived at Birkenau for six days; we were not even tattooed."

Mother and daughter were sent to labor in a factory in Rega, the capital of Lithuania. "We worked from 6 P.M. to 6 A.M.; another shift worked 6 A.M. to 6 P.M." Pepi recalls a disturbing detail: "The road we walked on from our barrack to the factory was paved with broken-up headstones—we could read the lettering—from the Jewish cemetery."

Pepi's physical strength and youthful looks helped her survive. "One morning in line-up they asked me, 'How old are you?' I said thirty-nine, but I was forty-six. The guard looked at me and said, 'You are a liar. You must want to be dead, rather than work for the Germans.' Then he lifted up my dress and looked at my legs and body. 'You must be only thirty-three,' he said. 'You will keep working.' So I was saved.

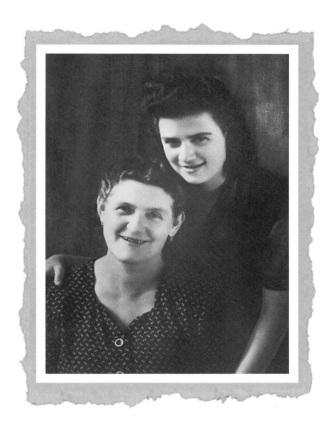

Pepi and daughter, Clara, after returning from camps, circa 1946

"We heard that the Russians were coming and we would be sent away," she says. The rumors were correct, and Pepi and Clara were put to work digging anti-tank trenches in the frozen ground, to try to defend against the advancing Russian forces.

"It was so cold, my hands were frozen," Pepi recalls as she describes their task. "Clara worked in the trench and I worked on the top. The trenches were about two-and-one-half yards deep, and one yard wide. One day a young man, one of the Hitler Youth, started to beat me, 'Can't you go faster, you old bag? We want to win this war. We don't want the Russian tanks coming through.' Clara got out of the trench and confronted this boy."

Clara interrupts, "I told him, 'This woman is my mother. She is working with barely any food; just a slice of bread and coffee in the morning, a slice of bread and coffee at noon, and at night a potato soup with not even a piece of potato, just peel.'"

Pepi continues, "Then, Clara looked at him and said, 'Don't you have a mother?' He was flabbergasted, silent. Then he said, 'Yes, but she's German,

not Jewish!' But the next day he came back and brought us a carrot and a cigarette. 'This will make you less hungry,' he said. Somewhere, he was touched, ashamed."

As the Russian army advanced, the Jewish prisoners were pulled along in retreat with the Germans. "We were marched for two days, with snow on the ground and holes in my shoes." Pepi describes their first ray of hope, "We came to a farmhouse in the middle of nowhere. When we were making dinner for the guards, Clara, who speaks German, heard them discussing what to do with us." Pepi recounts how the younger guards suggested various ways to kill their prisoners, "But an old man, who was more kind, said to save the bullets for the Russians. Finally, the young ones agreed with the old man to just leave us, thinking we would just die anyway. We were two hundred women in the middle of nowhere. The next day, January 24, 1945, we woke up without guards. So that's how we were liberated."

"My wish for my great-grandchildren is that they never know prejudice, either in their own hearts toward others or used by others against them. Hate and prejudice are terrible things."

Pepi, Clara, and about ten other women from their area began walking home. But the danger was not over. "The war was still going on. Russian soldiers were advancing. Each of us was almost raped, barely got away. We were afraid all the time, and hungry and cold, but we kept going," Pepi says, "because we wanted to get home to our families."

Finally, after four months, they arrived home. "When we were taken from our home, I weighed 190 pounds—stout and healthy," she says. "When we came back, I was 90 pounds."

"We were among the first liberated. In a very short time, men started to return." As each group returned, stories emerged to fill in the void of the separation. "My husband died five days before the end of the war, malnourished and sick. The man who was with him when he died told me," Pepi says. "Others told how my son had been shot almost immediately after we were separated."

The dream of having her family reunited had sustained Pepi through the ordeal. "I was always frightened and angry. I hated the Germans and wished them the worst. I hoped good would triumph, that we would be together soon. But mostly, I lost hope. Only God gave me strength to keep on, to care for Clara." Clara firmly believes that she and her mother survived because they nurtured each other throughout that time.

Pepi and Clara have lived together ever since. After the war, Clara met

and married a man who was the sole survivor in his family. They had one son. The family came to United States in 1962 to escape the communist regime. Pepi now has two great-grandchildren.

Remarkably, Pepi has not lost faith in mankind, or God. "I feel God gave a choice between good and evil. That was the problem. Some people choose evil, and it's not the fault of God; it is the fault of man," she says, then asks, "Why wasn't God a dictator for good only?

"My wish for my great-grandchildren is that they never know prejudice, either in their own hearts toward others or used by others against them. Hate and prejudice are terrible things."

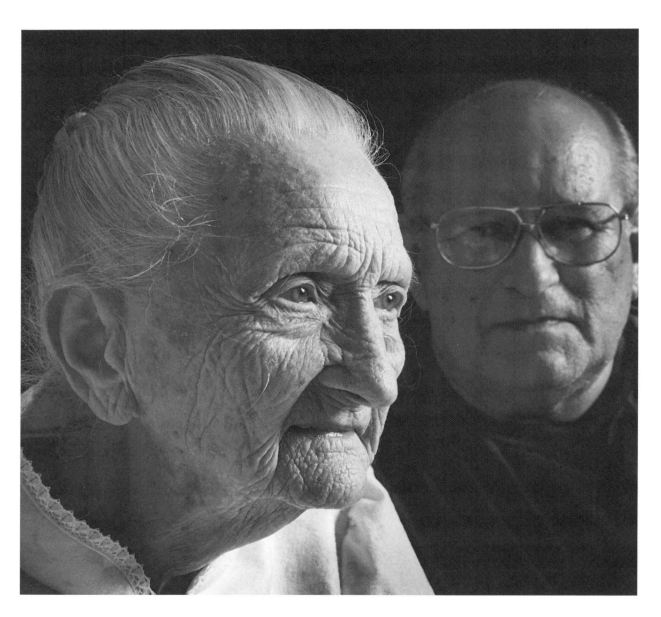

Esther Burney with youngest son, Pete

ESTHER BURNEY

BORN MARCH 26, 1898

Oklahoma Pioneer—The Burney family left its name on the Oklahoma landscape before it became a state. Born in Marlow, Indian Territory, Esther taught school before marrying a man of Chickasaw lineage and raising two sons.

"MY FATHER-IN-LAW helped organize the town of Chickasha and named it, too," Esther Burney says proudly. "The Rock Island Railroad came south from the little town of Minco and wanted a station where the railroad crossed the Washita River," she explains. "Since my father-in-law was the only Chickasaw, they gave him the privilege of naming the place. Oklahoma's got a town named for each of the other Five Civilized Tribes, too: Seminole, Muskogee (Creek Indians), Choctaw, and Cherokee."

Looking at Esther, with her weathered face and her white hair braided into a bun, you are reminded of the classic portraits of women who crossed the Plains in covered wagons to settle the frontier. Esther was born in the territory settled by those pioneers. Born nine years before Oklahoma gained statehood in 1907, her place of birth is listed as Indian Territory. Two personality traits that could be attributed to growing up on one of the last frontiers—her strong will and stubbornness—have probably contributed to Esther's longevity.

Independent thinking is a quality that runs in Esther's family. Her mother, Leota Ellen, was a divorcee with a son and daughter in the 1880s, before she married Esther's father, Henry Amos Falk. "In those days, divorce was really unheard of," Esther explains. "Little is known of Mom's first husband, except that he was a drunkard. My mother supported herself and her two children by taking in washing."

Henry Amos Falk also had a bent for independence. A German immigrant, he came to America to escape Bismarck's army. Esther describes how her father came to Oklahoma: "After he landed in New York, he worked his way out to Ohio where he worked in the ice business. They'd saw big blocks of ice from the lakes and haul the ice back to warehouses where they'd put hay on it for insulation. You have to remember that there was no refrigeration in those days," Esther says, with her flat Oklahoma twang.

"Well, my dad saved his money, bought his own team and wagon, and went into the ice business for himself. Then he took his profits and went out to Texas and opened a mercantile store. He did his banking in Fort Worth until a man came to his town, Alvord, and opened a bank. Everybody, my dad included, put their money in this new bank, and then this man absconded with all the money. So Dad decided to start over. He took the train up the line to Marlow, in what is now Oklahoma, which was a pretty good-sized town then—about three thousand people. Highway 81 now runs through where the train line ran," Esther explains as a way of placing her hometown on the map.

Esther's parents lived in Oklahoma the rest of their lives and raised nine children, including the two by her mother's first husband. Her father worked for a local merchant family, running a grocery store.

While Esther's memory of her childhood is dim, she expresses definite pride when recalling her own accomplishments as a teacher and the influence her husband's family had in shaping early Oklahoma history.

The Burney family came to Oklahoma in the mid-1800s when the Chickasaw Nation was forced to leave its tribal lands in Mississippi and resettle in what was then known as Indian Territory. Because the Burney family had been paid for their lands, they could afford to make part of their journey on a steamboat. "Burneyville, on the banks of the Red River, was named for my husband's grandfather. That's where they landed," Esther proudly declares.

To prepare for a teaching position, Esther attended a year of college at Central Normal School in Edmond, Oklahoma, and a year at the University of Colorado. Her first teaching assignment was in an oil-rich area south of her hometown.

"I taught third grade in Empire, an oil boomtown. The workers and their families flooded in. One day I had twenty-five students; the next day I had eighty," she says. "Life in a boomtown could get a bit wild. One time, when a student was raising a commotion, I found a pint of whiskey in his desk. After school, I went to see those parents. Well, his father turned out to be the town whiskey bootlegger—this was during Prohibition. On top of whisky bootlegging, the mother bootlegged oleomargarine. Only real butter was sold here legally then."

Later, Esther taught in her hometown. "I taught first grade in Marlow. It was a big school with teachers for each grade, not a one-room school. I never taught in a one-room school," Esther says with an obvious pride in the implied stature of these schools. "I just loved all my students," she comments. "Over the years, some of my students have gone on to be quite successful. There was a state representative who was a student of mine."

Esther met her husband when she was teaching in Marlow. "I taught school until I married Overton Burney in 1922. My husband was a whiz with numbers. He worked for the bank for a while, then he got a job working for the Creek Indians and we moved to Okmulgee, the Creek Indian Headquarters. That's where our younger son, Overton ("Pete") was born. Our son Bill was five years older."

Esther was a full-time homemaker and mother until the middle of the Great Depression, when economic hardship overcame the family.

"At the wrong time of his life, my husband was talked into going into business for himself. There was a new petroleum company, called Diamond—DX was the name of their stations—and he was talked into buying a distributorship. So, he goes into the oil business, and that lasted about six months before he went broke. This was in 1935, and the Depression was well under-

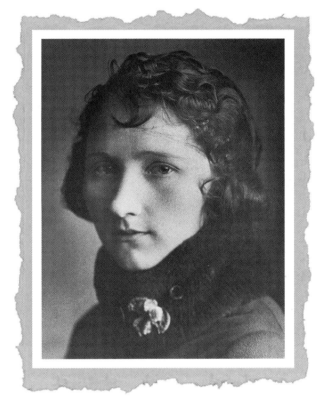

Esther, circa 1921

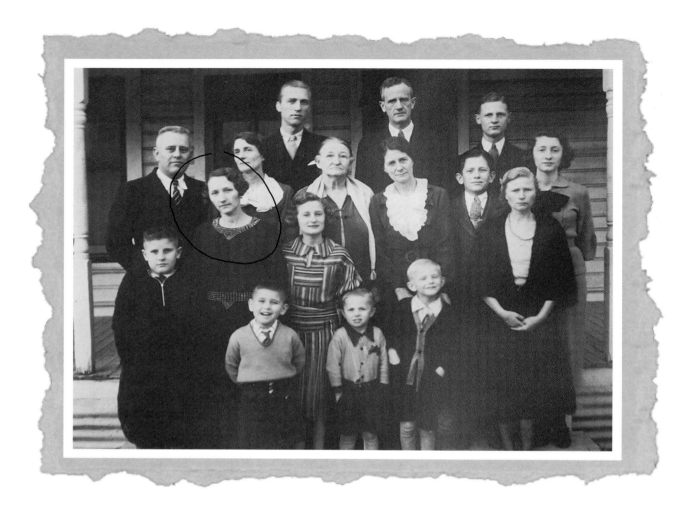

way. He had done well up 'til then, had a good job. He lost it all. It was touch-and-go from then until World War II started. We moved back to Chickasha and I went to work at a little grocery store for about five years. Then I went to work for Mr. Rothbaum, who had a men's clothing store. I worked there for about twenty-five years, until I retired in 1964."

The family's economic situation improved when Esther's husband was elected to the office of county clerk. He was continually re-elected and held the office for about fifteen years, until his death in 1956 from lung cancer.

Respiratory problems have affected both her sons as well. Esther recalls that the problems began in the 1930s: "We were living in town, so we didn't see the really bad effects of the Dust Bowl; but I did see places where the dust would form drifts up against the buildings, just like snow. In bad sand-storms, sometimes the boys would be sick for weeks; they both had respiratory problems. Bill died of emphysema when he was fifty-nine."

Esther's son Pete has recently been diagnosed with lung cancer; but

unlike in his father's day, he is receiving treatment that gives him hope for remission of the disease.

Esther has been free from serious illness for most of her more than 100 years. She recently blacked out and fell, breaking several ribs. Since then, she has moved in with her son Pete and his wife, Betty. According to Pete, that fall was the first time his mother ever used her Medicare benefits. She told the attending physician that her good health was the result of "staying away from you old doctors."

Genetics may also play some part in Esther's longevity. Her half-sister lived to be 102 and her younger brother was in his late 90s when he died. Esther, however, just shakes her head and states simply: "I don't know why I've made it this far or how long the good Lord is going to let me live. I'm just grateful to have made it past one hundred."

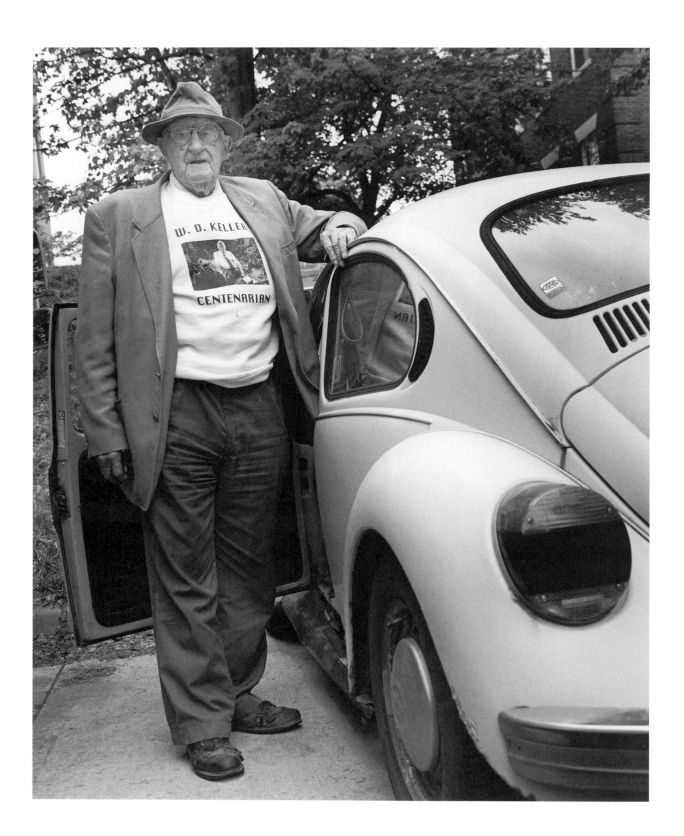

\mathcal{D}r. \mathcal{W}alter \mathcal{K}eller

BORN MARCH 13, 1900

Professor of Geology—Although mandatory retirement at age seventy put an end to his full-time teaching, Professor Walter Keller still comes to his office in the Department of Geological Sciences at the University of Missouri, Columbia, every day—driving his VW Beetle in rain, sleet, or snow if necessary.

AT AGE ONE hundred, Professor Walter Keller is slowing down—he no longer comes to his office seven days a week. Sometimes he even skips a whole weekend. Dr. Keller—only his contemporaries use his first name, and there are few of them left—has been a part of the geology department at the University of Missouri at Columbia since 1920, when he came there as a freshman student after serving in World War I. In 1970 the university had a mandatory retirement policy. So, although he is no longer teaching or officially on the staff, Dr. Keller continues to come to his office daily to be of counsel to students, to read scientific journals, and to keep up his correspondence with scientists all over the world. At least five days per week he drives his sky blue 1973 Volkswagen Beetle across town to his office. Neither rain, nor sleet, nor snow have kept him from coming in for the past thirty years since he officially retired.

The small office is crammed from floor to ceiling with evidence that this man lives a very full life. Although his wife, a registered nurse whom he met

through mutual friends, has passed away, and his two sons, three grandchildren, and three grandchildren, and three great-grandchildren are scattered across the map, Walter Keller is never far from the hearts of his family and friends. He continually receives a barrage of correspondence. His desk is piled with notes from former students, colleagues, friends, and family. Stacks of scientific papers and journals are also waiting to be read. The walls are adorned with slogans, greetings, and photographs. A birthday greeting of "long life" is written one hundred ways in Chinese. A sign declares: "Remember the first five letters count, not the last seven! LABORATORY." Another sign comments: "A clean desk is the sign of a barren mind."

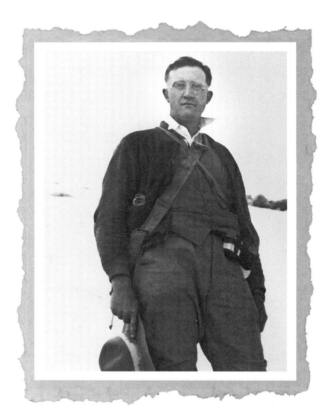

Walter, date unknown

Dr. Keller joined the geology faculty as an instructor in 1926. He earned three degrees in geology from the University of Missouri: an A.B. in 1925, an M.A. in 1926, and a Ph.D. in 1933. He also earned a B.S. in ceramic technology from the Missouri School of Mines in 1930 and an M.A. in geology from Harvard University in 1932. He has published more than three hundred scientific papers and traveled around the world twice attending and giving presentations at scientific conferences, studying geology, and serving as a consultant. He was one of a few select geologists chosen by NASA to study the Apollo 12 moon rocks. In 1981, the university named the geology department auditorium in his honor. "We wanted to name the geology building for him, but the university has a policy that we can't name a building for anyone who is still alive," explains Professor Glenn Himmelberg, chairman of the geology department.

Dr. Keller is very much a living legend on the campus. His fabled quest for knowledge is recounted in a story of his first days as a student registering for classes. A faculty member noticed what seemed to be a confused young man and offered assistance. Campus lore says that the then-twenty-year-old Walter Keller responded, "I can't seem to find the right class choices to fill every hour on the schedule."

During his student years, he supported himself working as an automobile mechanic. "I worked on Model T Fords," he recalls. "I just learned from watching the other mechanics at the garage at work."

Dr. Keller sees nothing unusual about his work ethic. Raised on a farm, where hard work was the norm, he also credits his childhood surroundings for his interest in earth sciences. "I got started on the farm, living close to nature. Of course, I never heard of geology until I was at the university, but on the farm I saw things that interested me without recognizing that they were part of what you study as a geologist. Then later when I got into geology, it began to take shape and organize itself—things connected and made sense."

It is this ability to connect the everyday world with the science of geology that made Dr. Keller an effective and popular teacher. In his flat, Midwestern drawl, he modestly explains his teaching philosophy: "I wanted the students to be enthusiastic about the subject, to embrace it. So, I'd try to show them how geology was an important part of their lives. At the first class, I asked them, 'What was the first thing you saw when you woke up and looked at the ceiling? You saw plaster, and that's geological material. You looked out the window, and the glass is geological material. When you went out and walked on the sidewalk, that's geological material.' So, they could see that geology is part of our everyday lives. It's a never-ending part of our lives."

"I worked on Model T Fords," he recalls. "I just learned from watching the other mechanics at the garage at work."

Dr. Keller always considered that he was, as he says with his dry wit, "teaching students, not geology." And that ability to focus on the one learning, not just on what was being taught, led Dr. Keller to develop an innovative approach to personalizing the large lecture classes that became common from the 1960s onward. When teaching an introductory geology seminar to three hundred students, Dr. Keller devised a method for making the class an intimate give-and-take colloquy. At the beginning of each class, Dr. Keller would draw eight numbers at random and the students assigned those numbers would sit in the front row. Dr. Keller then directed his teaching primarily towards those eight students. "It would be a different group of students each day, and they could ask me questions and I could ask them questions," he explains. "And that made it our class rather than me being with a bunch of three hundred." Dr. Keller referred to this system as "The Big Eight, after Missouri's athletic conference." This method kept the discussion lively and kept the students on their toes because they never knew when they would be one of "The Big Eight" at the front of the class.

The way in which Dr. Keller's concern for his students went beyond the classroom is best illustrated by the newsletter he started, with his own funds, for his students who were called into service during World War II. In May

1942, Dr. Keller began a mimeographed correspondence that circulated around the globe. His wit, illustrated by his clever way of relating geology to current events, comes through in the inaugural issue of the "Tiger Collecting Bag," when he wrote:

A major diastrophic movement beginning in Early Pearl Harbor time has deformed the 'strange ellipsoid' along its axes, Adolph, Tojo, and Benito, and we are out to restore isostatic equilibrium. As we pound the outcrops and throw specimens into the collecting bag some of the labels are likely to be switched. . . . In order to keep the labels straight . . . please send me your change of address . . . I will try to pass it on for the benefit of the fellow on the other side of the mountain. . . .

The "Tiger Collecting Bag" was a major success, reporting the non-classified activities of students scattered from the Solomon Islands, to North Africa, to France. The newsletter also chronicled the university's contributions to the war effort, listing professors who were on special duty in cartography and geology and the addition of crash courses on cartography and interpretation of aerial photography. Dr. Keller also stimulated dialog among his group, posing questions on the post-war future and importance of geological sciences. In the pre-email era, the smudged, ink-spotted, typewritten pages posted the eager responses from around the world. It is easy to see that Dr. Keller succeeded in his mission to boost morale. And it is equally easy to deduce why Dr. Keller is so loved by his students and colleagues.

The students' correspondence echo Dr. Keller's wit, and geology is a common theme. A student stationed with a bomber squadron in India in 1944 wrote: "I really don't get to see any geology very close, but we have had some close calls with some mountain peaks . . ." From the Pacific: "Just fighting off disease is a major problem in addition to Tojo's boys. This island here seems to be igneous and metamorphic, while coral life abounds . . ." And from Europe came the reports: "I have traveled over a lot of geology here in France both in vehicle, on my hands and knees, and on my belly. I have no time for a careful and thorough examination . . ." And: "Just a note from the Italian front . . . on several occasions I have found myself in very close proximity to the local geology and wanted to be a darn sight closer."

Dr. Keller was very pleased when he could forward good news, and particularly when students wrote that the newsletter had enabled them to meet up with each other. But, more somber messages were also conveyed: "It seems that one 88 had my number, so I am now reclining in a hospital in England. . . . I guess it will sound terrible to you when I tell you that I lost

my right leg about four inches below the knee, but when I learn to use an artificial leg, I expect to be able in time to walk without a limp. I don't expect it to hamper my geological career at all."

In August 1945, Dr. Keller's contribution to the war effort became more direct. He wrote: "Probably this will be the last letter from me for several months, because . . . I had a phone call from Washington, D.C., asking if I would be available for a four-month's stint as a . . . civilian instructor in geology at the Army University Center in Florence, Italy. . . . I would enjoy seeing all of the fellows that happen to be in that part of the Mediterranean theatre."

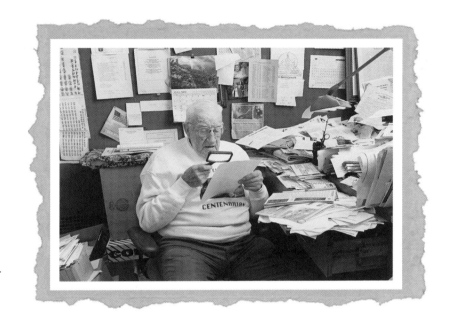

Dr. Keller recently had an opportunity to be reunited with many of his geology fellows when the university celebrated his one-hundredth birthday. Students, colleagues, and family from around the globe gathered to pay tribute. The highlight of the event was the announcement of the Walter Keller Endowment for Opportunities for Excellence. The geology department began its fundraising efforts a year in advance and the goal of raising $100,000 was surpassed—with Walter Keller contributing the first $1,000. Dr. Keller, obviously pleased with the honors and attention bestowed upon him, modestly shrugs off compliments, stating, "My philosophy is just always do the best you can."

Although the list of his awards and accomplishments fills pages, he does not dwell in the past. Dr. Keller believes in staying active—mentally and physically. He still walks every afternoon after his office hours. When he did geology fieldwork, he often scaled mountains. He thinks that exercise, a good diet emphasizing vegetables, and never having smoked have contributed to his longevity. He is philosophical about being a centenarian: "As you get older, you can't always think clearly or remember things immediately, but I don't know as we have much choice about it." With his typical dry wit, he says, "I'd rather keep active with geology than be a part of the earth."

Macedonia Cenatiempo

BORN SEPTEMBER 12, 1899

Homemaker—Macedonia Cenatiempo loved learning English when she moved to Arizona at age ten from her native Mexico. She worked as a sales clerk before her marriage to an Italian immigrant vintner.

"I LOVED IT IN this country right away. Coming here, it seems like I had come home. I loved learning the language. English was so intriguing that I learned fast," says Macedonia Cenatiempo, recalling when she began school in Douglas, Arizona, ninety years ago. "I never had any problems. Nobody ever called me names because I was Mexican."

Macedonia came to the United States from Chihuahua, Mexico, in 1910, traveling by train with her two older sisters and her widowed mother. They joined one of Macedonia's older brothers and his family. He was working for the railroad in Arizona and sent for them. Macedonia says her family immigrated because, "We were very poor, and there was much unrest in the countryside at that time because Pancho Villa was starting the revolution.

"I learned to read and write and do figures in Mexico. I was excited by English because it was so different. I remember going home and saying to Mama, 'Guess how these people pronounce the "J,"' because we didn't have that sound in Spanish, and it was so fascinating to me." Macedonia speaks with a soft, musical accent and her "J" sound does have a slight Spanish soft-

ness to it. Spanish was always used at her mother's home, so Macedonia retains some of the Spanish rhythm in her speech. Today, she still switches back and forth with ease, giving instructions to her health aide in Spanish and then returning to a conversation in English with her youngest daughter, Josephine.

New customs also fascinated her as a young girl. "I remember being surprised when I found out that most people were not Catholic. I came home from school and said, 'Mama, did you know that these people are all Protestants?' My mother was a staunch Catholic, but I was not. It was all so interesting to me, so new." There is still a sense of excitement in her voice as she recalls these childhood events. Her daughter, Josephine, observes that Macedonia has never lost her love of learning and her innate curiosity—which have kept her mentally young.

"We were very poor, and there was much unrest in the countryside at that time because Pancho Villa was starting the revolution."

"I had to leave school after the eighth grade. I had to go to work. That's what you did then," Macedonia states matter-of-factly. "I have a granddaughter who is a teacher, and she says that today kids don't appreciate school, but I did. I just didn't have a choice."

Macedonia went to work as a salesclerk in a five-and-dime store. "We sold a little of everything. At that time we waited on customers; we had to show them the merchandise. Now they don't do that. Their attitude now is 'you just buy or you don't buy; I don't care.'

"I mostly sold clothes, ready-to-wear." She giggles, "My job was to fit big women who wanted to be in smaller sizes." She mimics, "'Oh, this is too big for me.' Then I say, 'No, no it's just right; you look wonderful in that. It fits you nicely.' Anyway, that was my work. But," she adds emphatically, "I loved my work. Customers used to wait for me, just wait until I was available. I like people; I really like people. I believe I had no enemy in my life."

Her eager attitude in helping her customers was how she made an impression on her future husband. Macedonia and her mother had moved to San Pedro, California, where an older sister was living. She found work in a small department store there. "When he came in, I said to myself, 'There's a good-looking guy.' And I went up to him and asked him if there was something I could help him with. And he said no. Then, he asked for another girl, Anita. So, I was disappointed. But, immediately, he said that she was his cousin. So then I was okay." She still smiles broadly when she remembers that meeting. "So I started stalling around, like I couldn't find her, so I could talk to him more."

Macedonia's charms worked, because Giuseppe soon returned to visit his cousin and inquire about the friendly salesgirl. "Then one time he stopped and talked to me. I thought my heart would jump out of my chest, I was so excited. I don't even know what he said to me," she laughs.

An informal courtship soon began. "From then on he came into the store regularly. He escorted me home. I was raised very strict. So I only let him walk me to the corner near my house because I knew my mother would ask, 'What are you doing with that guy?' After a year, he wanted to meet my mother. 'Oh boy,' I thought to myself." Macedonia shakes her head, remembering how straitlaced the social rules were. "My mother used to say, 'A girl is like a delicate flower. You must never let a man touch you because you wilt.' So, that is all the information I had about anything sexual. Mama didn't know how to tell me anything else."

However, Mama did approve of Giuseppe, and soon was chaperoning the couple on outings. "He had a little Ford, and we had never been in a car before. He took us down to the beach. I thought I was flying at twenty-five miles an hour," says Macedonia of their dates.

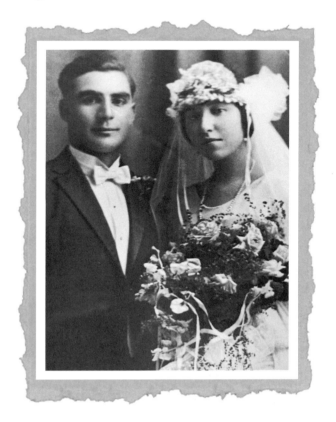

Macedonia and Giuseppe, wedding day, July 29, 1923

The only objection came from Macedonia's older sister. "She asked me, 'Are you going to marry a foreigner?' She didn't think I should marry outside of my race. But I didn't care that he was Italian. We were all foreigners in America," Macedonia states. "Later I learned that it was a very different culture. I had to learn to cook Italian food. I never even cooked anything because my mother spoiled me. But I got really good at it."

Giuseppe Giovanni Cenatiempo and Macedonia Martinez had a big church wedding with five bridesmaids and five groomsmen on July 29, 1923. Their first daughter was born in the first year. By the time they celebrated their fifth anniversary, there were three daughters and a son in the family. The youngest daughter, Josephine, was born in 1936. "One came out, the other one went in," Macedonia quips, describing the advent of her children. "And the deliveries weren't easy either. I had them all at home with a midwife, and some of them were breech. With four babies crawling around, I got ulcers." However, Macedonia now enjoys the rewards of her labors—twenty-one

grandchildren and fifty great-grandchildren. She and Giuseppe were married just six months short of their sixtieth anniversary when he died in 1982, at age eighty-two.

"Patience is the secret to a long marriage," she says, then adds with a little wink, "You also must be a little tricky, or I should say diplomatic is a better word. You keep the balance. And after so many years, you start to think alike."

There was a traditional division of labor in the Cenatiempo household. "He was very macho," Macedonia comments, "but I didn't mind, because I was the boss of the house." Giuseppe, a vintner, was the boss of the business. Because of prohibition, he did some creative marketing to make his enterprise successful. "He sold the grape juice in two-hundred-gallon barrels. It was unpasteurized, so people could ferment their own wine," Macedonia explains. "He also sold bottles and corks. But he never sold wine. He didn't want to do anything illegal." Giuseppe had learned this trade from his family in Italy, and most of his customers were of Italian decent. She concludes, "He began with two hundred acres that he leased, which were planted in grapes. He cared for the vines and harvested and crushed the grapes. He always made wine for his own family, but never to sell—even after the law changed."

Macedonia, circa 1914

Just when the household was settling into a smooth routine, with the four children all in school, Macedonia suffered a great crisis. Her mother died, and Macedonia found her whole world shaken. "I was the baby and I was very attached to my mother," she says. "After my mother died, I didn't know where God was. I used to cry and cry, and I asked, 'God, wherever you are, please help me.' But I couldn't find any answer." Comfort came from the counsel of a solicitous neighbor. "She told me all about death, and that it was such a natural thing. And it was a good thing when you're ready. She said that we must not grieve about our people when they are gone because they are better off. What she said made so much sense to me."

The neighbor and her husband were Mormons, and had been missionaries. Macedonia explains her newfound faith: "I had so many questions

about that church, I didn't know what was Mormonism, but I liked it. It helped me understand God." Two years later, in 1935, after studying the teachings, Macedonia was baptized in the Mormon church—with the permission of her husband, who did not embrace that faith until he was eighty years old.

Her faith and a positive outlook on life, Macedonia feels, are what have enabled her longevity—and a commitment to taking care of herself. "I always exercise. I used to walk a lot, even after we got a car, and work out with my arms and legs," she states. Now, since she has lost both her legs from complications of diabetes, she lifts weights. "I can wheel myself in my wheelchair and I lift myself up to sit on the potty. The more I do, the better it is for me. The less you do, the less you can do," she states, showing off her biceps.

"What is sad about being one hundred," Macedonia admits, "is losing my husband, my family, and my friends. I don't have any more friends alive. Making friends is not easy when you get old. You have to tell about so many things. And then you're called old-fashion. I'm not old-fashion. I keep up with what's going on, I watch the news.

"But, I feel grateful to live in this country and to have had such a good life," she states. "My best advice is don't think about anything that is negative."

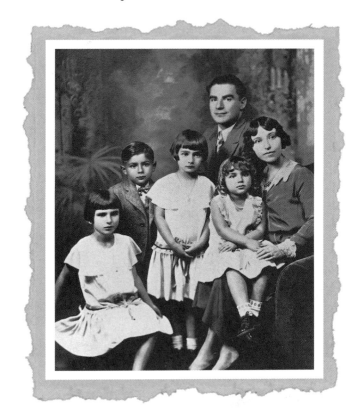

Cenatiempo family,
circa 1932

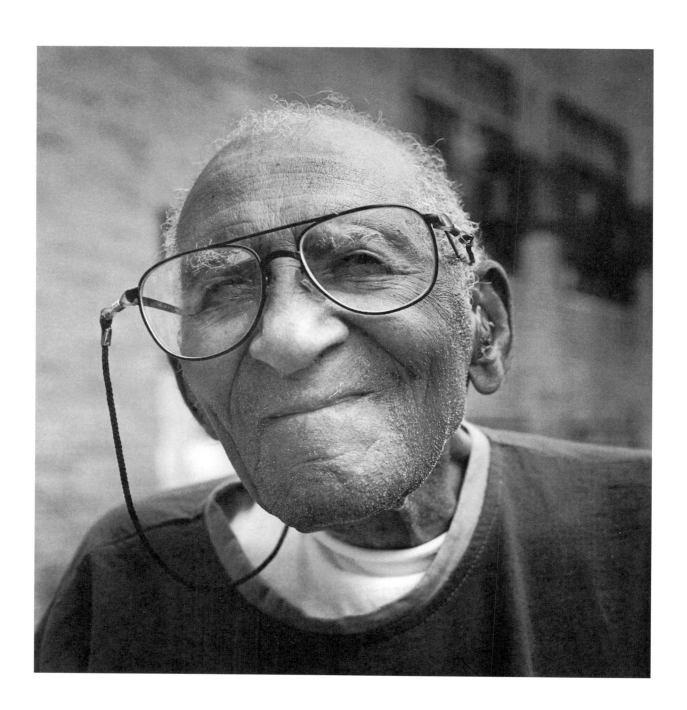

HERBERT YOUNG

BORN MAY 1, 1886

Veteran and Auto Mechanic—Herbert loved learning a new technology, electricity. Beginning a career as an automobile mechanic in 1909, he repaired every model: Pierce Arrow, Nash, Packard, Ford, Pontiac, Chrysler. He later used his mechanical and electrical engineering skills as a building superintendent, a post-retirement job he held until age ninety.

IT IS EASY to see why, although born in 1886, he carries the moniker Herbert "Forever" Young. Herbert Young does seem to be forever young. Although he uses a walker, his stride is sure and steady. His memory is equally clear whether recalling events that happened one hundred years ago or his appointment for this afternoon's card game. Genetics may play a part in his long life—his mother lived past one hundred. But Herbert has his own opinion.

"The secret of living a long life is how good you took care of yourself when you was young. If you didn't abuse yourself, you'll be okay. But, kids nowadays do every damn bad thing; they smoke, drink, do dope, have sex, everything bad.

"When I was growing up, the only thing I was interested in was a good education. And, thank God, I got one—and it has served me well my whole life. When other boys was out playing, I was home studying.

"After graduating from Mechanic High School, I went two years to Wentworth Institute of Technology. I learned electrical engineering—how to wire houses and work on motors. I liked to learn about everything that

was new. I started working as an automobile mechanic in 1909. I worked on all kinds of cars: Pierce Arrow, Nash, Packard, Ford, Pontiac, Chrysler."

Herbert was born in the West Indies. His parents separated when he was an infant and his mother immigrated with him to Boston.

His mother instilled in him a strong sense of responsibility. To this day he says with pride, "As long as I can get along by myself, I don't ask for nothin' from nobody. I always try to take care of myself. There's a lot of people not even my age who don't get along like I do. I'm always on the go." Indeed, Herbert only slows down when he sits in the park with a good book—one of his favorite ways to spend a summer afternoon. He declares, "I like action— dancing, playing cards, shooting pool."

A decorated World War I veteran—and recent recipient of France's highest military honor, The Cross of The Legion of Honor, in appreciation of his service there—Herbert has seen another type of action. Herbert's all-black regiment, the 807 Pioneer Infantry, was shipped to the front near Château-Thierry and fought in the Argonne-Muese offensive of 1918. During his military service he was shot and exposed to chlorine gas, which caused him permanent lung damage. He vividly recalls his experiences in France:

"I volunteered for the Army because all the boys was going. When we first got to France, the U.S. Army didn't want us to fight with the American white boys. So, they put us with the French soldiers. We fought with the French army until almost the end of the War.

"There's nothing good that I can tell you about the War. We did a lot of killing in the First War. I was in the trenches for eight months—nothing but water. I would say 50 percent of the boys died from sickness. I remember one December we had a delousing and had to take a bath out in the open, and it was freezing. We had a tough time in the First World War."

After his discharge from the Army in 1919, Herbert returned home and married his sweetheart, but times were tough at home, too. He really felt the sting of racial prejudice.

"The colonel told us we would have a tough time when we got home; it was hard for the Negroes at home. No jobs for Negroes, even as shoeshine boys. As a serviceman with a good education and a good trade, the best work I could find was in the Post Office.

"After everything I did in the service, I didn't take nothin' from nobody. I had some arguments with the supervisor, so I punched him in the nose. After that, I couldn't get no work in Boston. So, I came down to New York in 1927. I couldn't get a license as an electrician because I was black, but I got a good job at an automobile dealership. I was their head used car mechanic

for twenty years. I took on extra jobs painting houses and fixing things, so I did pretty well.

"Even in the Depression, I made twenty-seven dollars a week—about the best a black man could get," he says, proudly. "We paid eighteen dollars a month for our place, five rooms. We lived on 136 Street, off Eighth Avenue, a real nice neighborhood. We had gas light, but I put electricity in the house. There was electricity in a house about six houses down and I went into the cellar and ran the electricity over to my house.

"If you went to the market with five dollars, you'd come out with so much meat you couldn't use it; twenty-five cents a pound for the best pork chops, fifteen cents a pound for beef steaks," he says, shaking his head in disbelief at today's prices.

To Herbert, part of providing a good life for his family meant making sure his sons were brought up right. His philosophy might be considered old-fashioned today, but he's proud of the way his sons were raised. "I wouldn't let my wife work," he declares. "She needed to take care of our boys and make sure they didn't get in no trouble. Thank God, neither of them never did get in no trouble. My wife kept a tight yoke on them. Both of my sons are dead now— and the funny thing about it, they were born four years apart and they died four years apart. My wife died back in the '40s."

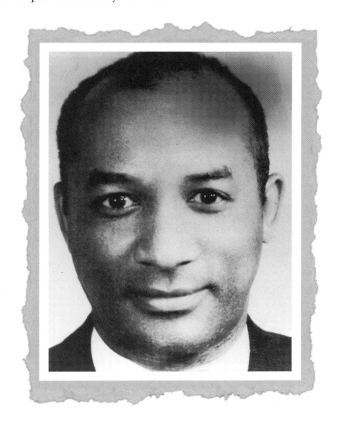

Herbert, date unknown

Independent and feisty, Herbert didn't remarry until he was in his nineties. After an attack of appendicitis put him in the hospital, his doctors told him that they did not think he should be living alone, so he and his ladyfriend tied the knot. Having the care and companionship of his second wife, Grace, has contributed to his longevity and enjoyment of his centenarian years.

Herbert continued working long past the traditional retirement age. "In 1969—when I was eighty-three—I got work as a superintendent for three buildings," he boasts. I worked 'til I was over ninety, then I couldn't get no jobs." He explains, with a sigh of regret, "They said I was too old for their insurance to cover me."

This is one centenarian who is like a perpetual motion machine—each movement triggering another, keeping up a constant momentum.

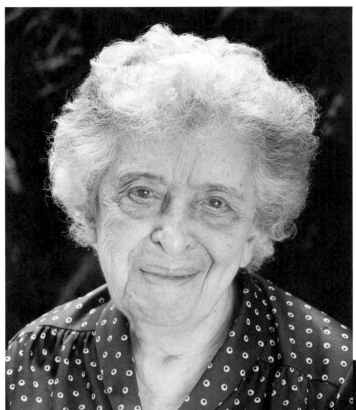

Jean De Angelis

Mary Delfino

JEAN DE ANGELIS AND MARY DELFINO

BORN FEBRUARY 14, 1899

Fraternal Twins—Born in Brooklyn, New York, Jean and Mary have led very different lives. Mary chose to be a full-time homemaker and raised two sons. Jean never married and worked as a seamstress at Warner Brothers. Although they do not live together, the sisters are on the phone to each other several times a day.

MARY DELFINO AND her fraternal twin sister, Jean De Angelis, are not your stereotypical image of twins. They are as different from each other as any two sisters might be. Nor do they look any more alike than any other two sisters. Yet, what most people don't realize is that they are the rule, not the exception, when it comes to twins. Two-thirds of all twins are fraternal—or non-identical.

Still, as twins and especially as centenarian twins, they are a rarity. In the United States, before the advent of fertility drugs, only approximately two percent of all births resulted in twins. Those American twins who have reached centenarian status together may be fewer than a half-dozen. Worldwide there may be fewer than a dozen living sets of centenarian twins. The oldest known surviving twins were Japanese identical twin sisters, Kin and Gin Kanie. Kin, the older twin, passed away at age 107 in January 2000.

But Jean and Mary do not make a big deal out of being either twins or centenarians. They both agree that they were equally close to their other two

sister Laura also moved West, and worked as a nurse. Their sister Frances was already living in the area and was married to a cameraman at Warner Brothers movie studio. He helped get Jean a job as a seamstress in the costume department there. "She worked on costumes for Betty Grable and Olivia de Haviland, including some for *Gone with the Wind*," says nephew Anthony Delfino.

Jean says she doesn't recall specific costumes. "I worked on so many. When you have a job to do, it's none of your concern whether it's 'Gone with the Wind' or 'Gone with the Sun.' You just have a job to do. You know what I mean? Your job is to do your work. Whatever came along, we just pitched in and we did our work. And sometimes we worked till 3:00 o'clock in the morning if it was necessary. If that garment had to be out in the morning, we had to stay until it was done because you couldn't keep the whole studio waiting for your work. But when we stayed late, they took us home in a limousine—which was very nice. It was a good job because you were always working on something different, not like in a regular dress factory where you make the same dress over and over again."

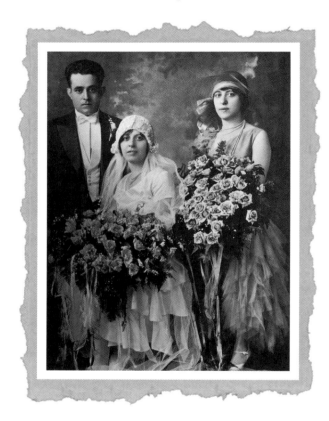

Wedding of Mary and Rocco Delfino. Jean De Angelis, maid of honor, 1929

While Mary chose the domestic life, Jean remained a career girl and never married. "I didn't feel that I ever met anyone who I wanted to get attached to. I had plenty of opportunities, and they were all good people. Let's put it this way: if they weren't such good catches or if I didn't have any choices, I might have felt there was something wrong. But these were all fine people; they just didn't suit me. It hasn't bothered me one way or another. It would have bothered me if no one had cared for me. But some people are meant to get married and some are not."

Although both sisters are devout Catholics, they don't credit their centenarian status to prayer. They both say they just live one day at a time. "I tell you, when you get this old, you can't expect anything anymore," says Mary, who suffers with arthritis. "You just hope today you live. Tomorrow's another day."

Jean is more philosophical: "I would say that faith in your God is the most important thing. And doing God's will. You put those two things together and your life is going to be good. Because if you're living according to God's will—and I don't care what religion you're in—you will be happy. What I mean is, treat people right and do the best you can with whatever is given you. And accept that you will have your differences with people, but don't let them get in the way. Whatever God sends your way, accept it.

"I just lived my life the best way I could. Living to be one hundred, that's not an idea that anybody could have—nothing you could plan for. God just gives you the years, and that's it. You accept it. And that's all you can do about it. What else can you do?"

She gives a hearty laugh. "When I was younger and had to work such long hours, I would be so tired that I would say, 'I feel like I'm one hundred years old.' Well, it isn't as bad as I thought it would be!"

"Treat people right and do the best you can with whatever is given you."

JANET LEWIS

BORN AUGUST 17, 1899

Poet and Novelist—Janet was born in Chicago, Illinois. Her poetry was first published in 1918 in the University of Chicago student newspaper. In addition to poetry, her first love, she has written novels, short stories, children's books, and libretti for several operas.

THERE IS SOMETHING very soothing about being with Janet Lewis, sipping Earl Grey tea in the living room of her California Spanish-style bungalow. Being with Janet feels refreshing, like walking through a peaceful, verdant garden; the beauty is in the subtlety, not in bright, colorful flowers that scream for attention. The chaos of the world does not invade Janet's carefully balanced universe. Calm, yet complex describes this woman. Janet, an acclaimed poet and novelist, seems completely comfortable with herself—and with her age. This sense of ease is contagious.

Janet Lewis' poetry was first published in 1918 in the University of Chicago student newspaper. Her poems have been published continually throughout the twentieth century and now into the twenty-first. In addition to poetry, her first love, she has written novels, short stories, children's books, and libretti for several operas.

Underlying all of her work is a love of nature and a keen sense of observation. Her work is rich with descriptions of the everyday; she makes the

commonplace uncommon. Her poem, *Early Morning,* shows how she sees her environment, sensing a balance and interdependence in the universe:

The path	*The path*
The spider makes through the air,	*The light takes through the air,*
Invisible,	*Invisible,*
Until the light touches it.	*Until it finds the spider's web.*

Janet's love of nature and of writing are gifts from her family. Her childhood home was filled with books. Her father, Edwin Herbert Lewis, a teacher of English and writing, took his family out of Chicago every summer to the forests and lakes of Michigan's Upper Peninsula, where the family had a lodge.

Janet was almost destined to become a writer. "I don't know what drew me to writing; it just seemed to fit," she reflects. "My father used to tell my older brother and me stories when we were children. That just seemed a natural thing for a father to do. I remember asking him to write them down, but he said he didn't have paper and pencil. So, I took my savings and went to the local store and got him paper and a pencil. And he did write them down. So, the idea of writing down stories came to me early, and I did try writing little stories of my own as a child."

Janet attended high school in Oak Park, on the edge of Chicago, a locale made famous by one of her schoolmates, Ernest Hemingway. She and Hemingway contributed to the same school magazine called the *Tabula.* But Janet doesn't align herself with celebrity. "His sister, Marcelline, was in my French class for three years, so I was aware of Ernie. He was born the same year as I was, but he was a year behind me in school. I think he dropped out and did newspaper work for a year and then came back to school."

This nonchalance toward fame is typical. Although her list of famous writer friends reads like a "Who's Who" in the world of poetry and prose, Janet values the friendship, not the reputation, of each person. "When I went to the University of Chicago, I was in the Poetry Club," Janet says, "and a lot of the members became well known. And most of us remained friends for the rest of our lives."

The most important of those early friendships forged though the Poetry Club was the one with her husband, Arthur Yvor Winters—known as Yvor. When Janet joined the club in 1919, her future husband, recouping from tuberculosis in a sanitarium in New Mexico, was corresponding with members of the Poetry Club, to which he had belonged earlier.

"We sent him our poems, and he criticized them and wrote us back. So, in a way he was a member of our group," Janet recalls. "When he got well enough, he came back to Chicago in 1921 on a visit, and we met. I looked forward, with great anticipation, to meeting him. After that, we became individual pen pals." They became engaged in 1923 and married June 22, 1926.

In the meantime, Janet earned her Bachelor of Philosophy degree from the University of Chicago in 1920 and went to Paris as a graduation present. Janet recalls this trip fondly as one of her best adventures. "My family gave me a ticket to France. The ship was lovely and the voyage was very enjoyable. The third class was full of Europeans returning home now that the War was over, and they were all very happy. I spent a lot of time in the third class, on the big open deck, which was better than my cramped second-class quarters.

"I got to Paris knowing that my money wasn't going to last forever, so I scrambled around and got a job at the American passport bureau. Many Americans were going to Constantinople on the Orient Express and had to have a visa for every country they would go through.

"There were a number of working artists in Paris then. Hemingway and that group came later, but artists were there from England and a few from the U.S. I sublet a studio apartment from an English painter. The studio had been handed down from one artist to another."

When she returned home, Janet taught and briefly worked for *Redbook* magazine. In 1922, the same year her book of poems, *The Indians in the Woods,* was published and she began to receive notice, her career was interrupted. Janet was stricken with pulmonary tuberculosis. She was sent to the same sanitarium, Sunmount, in New Mexico, where Yvor Winters had been when he was writing to the Poetry Club. Janet still thinks of her time recuperating from TB as having changed her outlook on life.

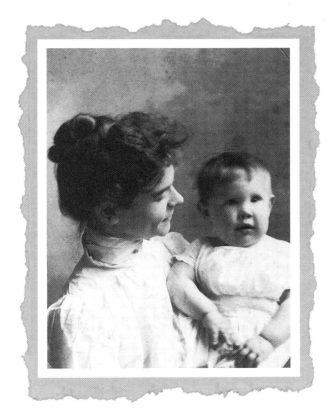

*Janet with her mother,
Elizabeth Loxley Taylor
Lewis, 1900*

"I was in a sanitarium for almost five years. Tuberculosis takes all your energy; a letter a day was major work. Fortunately, I made a complete recovery; I don't even have residual scar tissue. But I remember thinking, 'Can this be the end?' So many people were caring for me, concerned that I get well,

that I also had a certain sense of security. It was an amazing experience.

"Being sick taught me to be patient and not be discouraged; it gave me a sense of balance. I learned important, lifelong lessons by being put to bed for a few years. You cannot let yourself become discouraged and you can't rush anything. I had to take it one day at a time. It was sometimes very frustrating, but I learned to be in control of my moods; being happy or unhappy is my own decision. If you let external things get you off balance, you can lose everything."

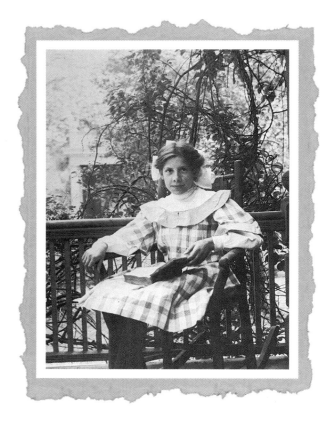

Janet, circa 1912

These lessons that Janet learned from surviving tuberculosis have contributed to her having a healthy, long life. Janet feels that the secret to living a long time is taking care of yourself. She says, "If you are sick, take time to get well. Even with a bad cold, don't walk around with it; do something about it." And she follows her own advice, resting daily and exercising. Swimming, Tai Chi, and walking—and even doing sit-ups—are part of the routine Janet has employed over the years. A hip replacement in her seventies to relieve arthritis pain worked wonders for keeping Janet active. She walks steadily, without a cane or other aid.

Janet was still in the sanitarium when she and Yvor married. Within a few months they moved to Palo Alto, California, and Yvor began working on his doctorate at Stanford University, where he eventually became a professor of English.

They were, by all appearances, a typical suburban couple—with a few twists. They raised a daughter and a son; Janet was the Brownie Troupe leader and the Cub Scout den mother. She kept goats; he bred prize Airedales. She hung out her laundry while chatting in French over the fence with her immigrant neighbor. She wrote; he wrote and coached poets and writers. They always supported and encouraged each other's art. Toward this goal, they published a literary magazine that they called the *Gyroscope*, which, Janet explains, "spins without tipping over."

Janet fondly recalls these early days at Stanford: "We published both of our poems and those of others—also stories, prose, poetry, and critical articles. The *Gyroscope* was all done by us—typed on our kitchen table, then mimeographed. We sold it for twenty-five cents a copy. We had wonderful

contributors: Katherine Anne Porter, Caroline Gordon, Allen Tate. But, after a year, I discovered that I wasn't doing any writing myself; that year I didn't write a thing. So, we decided that maybe the *Gyroscope* was a bit too much. We dropped it and I went back to my writing."

Her husband always supported her efforts. One form of encouragement that Yvor gave to Janet was a book of old legal cases, thinking she might find some good plot ideas within its pages. Her vivid descriptions bring these long-forgotten events back to life—and give her readers many philosophical dilemmas to ponder. In her work, she strikes a balance between telling a good story and teaching a valuable lesson. Three of her novels—*The Wife of Martin Guerre, The Trial of Sören Qvist,* and *The Ghost of Monsieur Scarron* (researched in France with funding from the Guggenheim foundation)—draw their plots from those historical legal cases.

"Being happy or unhappy is my own decision. If you let external things get you off balance, you can lose everything."

It is her steady, persistent pace and her sense of balance between home, family, and work that have enabled Janet's long journey down life's path. The death of her husband, her dear partner of forty-two years, in 1968 hit her harder than her own illness had. His presence still fills their home; the name on the mailbox still reads "A. Yvor Winters." Their book-lined study, in a small, cozy building in the back of the yard, remains equipped as it was when they worked there together. She still uses the trusty Royal typewriter. No word processors, fax machines, or even phones disturb this haven, which seems almost like a time-capsule of another simpler era.

Commenting on her own philosophy of life, Janet states, "My father's father was a Baptist preacher, but I was not taken to church regularly. I remember having a discussion with my mother about what is religion, and she said, very simply, 'It's what you believe.' I think my reason for living comes down to people; to be concerned about the people I love and to enjoy them."

Janet's wisdom, sense of balance, and humor are found in the advice she gives in her poem, "A Cautionary Note:"

> *We have long known*
> *His eye is on the sparrow*
> *But let us not be narrow*
> *Let us remember, and remembering smile,*
> *His eye is also on the crocodile.*

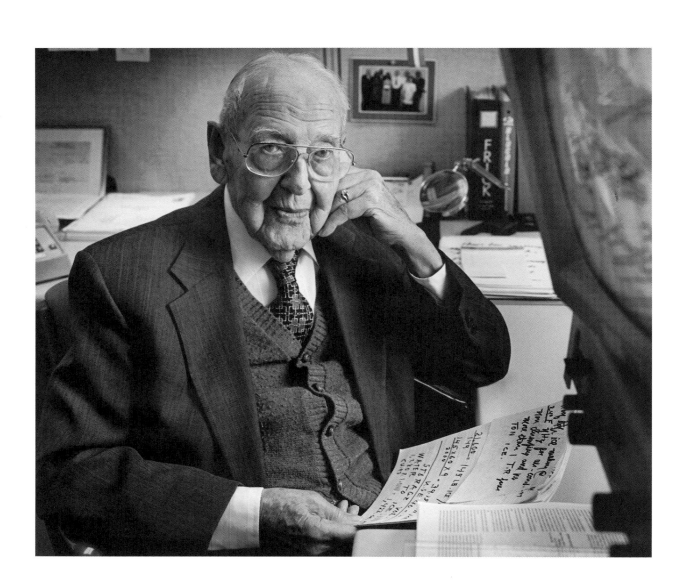

MILTON GARLAND

BORN AUGUST 23, 1895

*Mechanical Engineer—Born in Harrisburg, Pennsylvania,
Milton was recently honored as the oldest working man in the United States.
He has worked as an engineer for Frick Co., an industrial refrigeration firm, since 1920—
his first and only job. His work has taken him from gold mines in
South Africa to ice cream parlors in Philadelphia.*

KEEPING THINGS COOL has been Milton Garland's hot passion for eight decades. He began working for the Frick Company, one of the foremost commercial refrigeration manufacturers in the world, in 1920— fresh out of engineering school. He has worked there ever since, although he now only works until noon. His lifelong interest in what keeps machinery running has kept him going strong well past his one-hundredth birthday. He walks without a cane, and only stopped driving at age ninety, when his eyesight began deteriorating. He now uses a magnifying system that looks like a computer screen to help him read the myriad technical documents he reviews. He jokingly complains, "My hearing is a little weak, same as the rest of me!" Besides his twenty hours per week at Frick, he also consults for the Hershey Bears minor league hockey team; invented the compressors that make and preserve the ice they play on; and attends their games regularly.

"I love the work I am doing. I don't think age has anything to do with your desire or ability to work," says Milton, who was honored in 1998 as the oldest worker in the U.S. "As long as the company keeps me on, I'll keep

working. I retired in 1967, but I have been working as a consultant ever since. But if I had quit working, I'd be in my grave," Milton Garland declares. Clearly his work keeps him vital. "You see, I'm still learning refrigeration. It's a heat-exchange process, and different materials have different conductivity. There's always a chance of improving the heat-transfer rate."

"I retired in 1967, but I have been working as a consultant ever since. But if I had quit working, I'd be in my grave."

Milton has done much to "improve the heat-transfer rate" in applications as diverse as cooling a gold mine in South Africa or improving the manufacturing conditions for synthetic rubber to aid the U.S. efforts during World War II. He holds forty-one patents for his work.

Milton has worked at fixing machines almost all his life. However, his first job was in a different field. "I was carrying papers in Harrisburg when I was ten years old. I remember one time there was a delay in the delivery of the papers to the carriers. The newspapers I was to deliver were loaded on the streetcar, then the streetcar would dump them off at a certain street corner. Well, I remember I waited and waited. The grocery store on the corner where I was waiting happened to have a telephone, and they got the message from the newspaper people: 'Tell that boy the newspaper is late because of the San Francisco Earthquake.' It was 1906."

Milton's mechanical interests lead him to choose Harrisburg Technical High School for his secondary education. His new after-school job offered hands-on experience. "I worked at a bicycle and motorcycle shop not too far from where I lived," Milton says, explaining how he started tinkering with things for a profession. "In those days, the rims of bicycles were wooden and were easily broken. Well, the man who ran the place was also an electrician, so he was very busy wiring houses for people because everyone wanted to get electricity since it was new. As soon as I was out of school, I would go to the shop and take the wheels off of bicycles, unstring all of the spokes, and get them all ready. Then in the evening, I would put on the new rims and string them up. Soon, I learned how to re-string them."

Milton's work on bicycles led to work on engines. "The shop carried the Indian Motorcycles and that company offered training courses in Springfield, Massachusetts. So I went to my high school principal and asked him if I could get two weeks off to attend that course. He okayed the two weeks and gave me homework. He said, 'I'm going to give you an examination on these areas when you get back.' Yes, I had double work, but going to that course was one of the best things I ever did. While there were plenty of good mechanics who

could take apart motorcycle and automobile engines, most of them did not know how to re-time an engine. I learned all of that. The timing gears were the noisiest part of an engine at that time, and one of the gears was made of Micarta—it was the first of the plastic-type materials. That material was used to keep the noise down. But, of course, it was the one that would fail. It was a simple thing to put a new one in; but when you did, you had to time the camshaft with the crankshaft of the engine in order to get it to operate, and that's what many mechanics couldn't do. Often, I would just go and show them how to time the engine and set it in."

Milton soon learned that his love of mechanics could be lucrative. "When I completed that course, I was told that with my training I shouldn't take less than fifty cents an hour. Oh, my father used to get provoked at me about that. He had charge of the freight car repair shop for the Pennsylvania Railroad in Harrisburg. He said, 'I got all these people here, men with families of four or five children, and they're getting twenty-three cents an hour. You, little whipper-snapper, are getting fifty cents an hour.'" Milton indicates that there was a hint of pride in his father's protests.

Milton used his skills to build himself an Indian Motorcycle out of spare parts. After graduating from high school in 1915, he drove his new motorcycle to Massachusetts to begin Worcester Polytechnic Institute. He describes his alma mater proudly: "Worcester Polytechnic, where I chose to attend, was the major electrical training school where the Navy sent people to get more expertise in electrical work. There were five schools that the Navy had accredited. Cornell and MIT were two of the others." The school awarded Milton an honorary doctorate in his one-hundredth year.

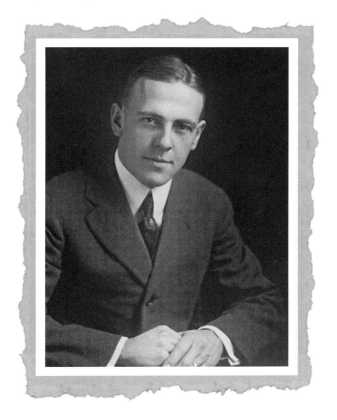

Milton, college graduation photo, 1920

At college, Milton's mechanical skills were again put to practical use earning an income. Here he had an opportunity to preview the type of large-scale machinery that was to become his life's work. "Four classmates and myself worked a night shift in the turbine steam engine electric power plant. With five of us, we each worked for two hours and slept the rest of the night."

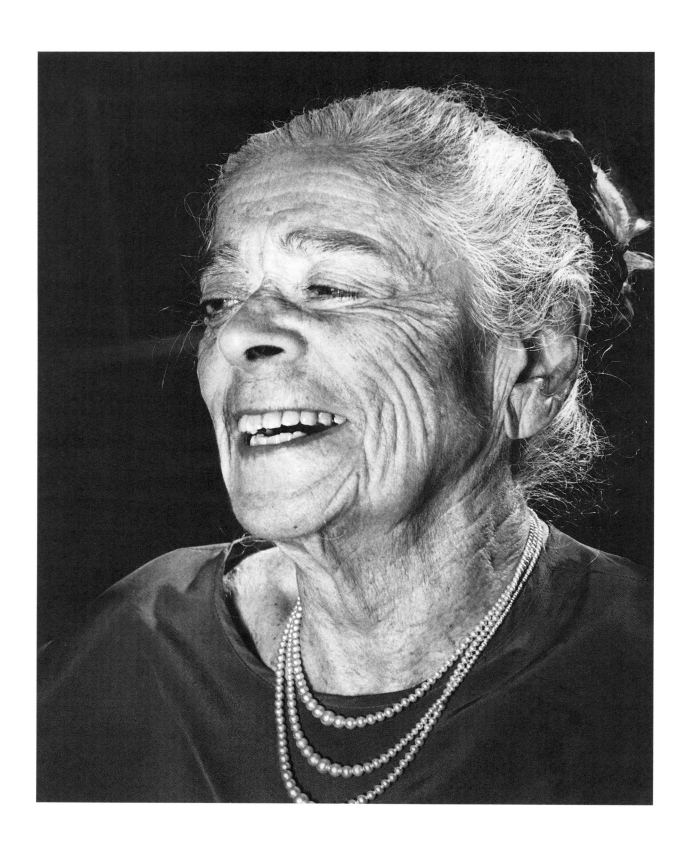

FREDERICA "FREDDIE" SAGOR MAAS

BORN JULY 6, 1900

Silent-Film Screenwriter—Born in New York, New York. Freddie is one of the last few living workers from the silent film industry. She was a screenwriter for MGM Studios in the glory days of Hollywood. Some of her films include The Plastic Age, *starring Clara Bow and* Flesh and the Devil, *starring Greta Garbo.*

FEISTY, OUTSPOKEN, OUTRAGEOUS, obstinate, and provocative—with a large dose of cynicism—is how all describe Frederica Sagor Maas, even at age one hundred. In the heyday of her career as a screenwriter in Hollywood in the '20s and '30s, she was labeled a troublemaker because she had the chutzpah to speak her mind to anyone, including powerful studio moguls such as Louis B. Meyer, whom she describes as "just another man with a big ego."

"If I wanted something, I went after it. And I was very good looking, which helps get you attention," Freddie confesses. "But, I never let anybody take advantage of me sexually, and I never slept with anyone because I thought it could get me a job. I was always treated absolutely correctly."

She still has an arresting appearance, with dramatic high cheek bones, piercing blue eyes, and striking white hair. Her voice, still forceful—with a tinge of a New York intellectual accent—sounds like that of a woman half her age. In conversation her memory and mind seem as sharp as ever, although she has a different perspective. "You could tell me something and five min-

utes later I will not remember what you told me," Freddie grumbles, "and I had a phenomenal memory, but the mind is tired."

Despite her claims of mental fatigue, she still exhibits the spunk she had when she quit her journalism course at Columbia University in 1919 to become an assistant to the story editor of Universal Pictures, because she was bored with college and impatient to discover real life. Strong-willed and stubborn as ever, she complains irritably, "I'm losing my sight—macular degeneration—and I can't read. It takes me so long now to do anything because I have to wait for other people to help me. I don't like losing that independence. I'm not good at adjusting my habits. I have to be honest with you; I'm not the same gal I was even a year ago."

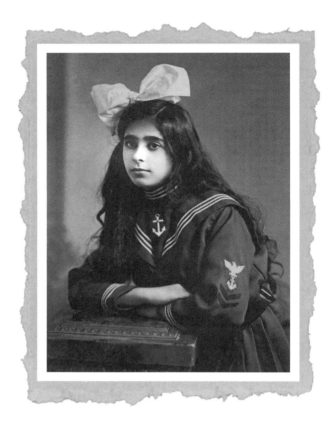

Freddie, 1913

Freddie, the youngest of four daughters of Russian immigrant parents, cites her mother's strong-willed personality as the mold for her own forceful demeanor. Arnold and Agnessa Zagorsky (anglicized to Sagor) were a Jewish father and a mother of prominent semi-noble status. Going against the mores of the times by marrying a Jew, Agnessa stoically refused to obey a governmental edict that all Jews must be removed from Moscow to a shtetel, and decided that her family must leave for America.

Once in New York, Arnold struggled in the garment business while Agnessa became very successful by continuing her career as a midwife, and was ahead of her time in insisting on hygienic conditions. "My mother was a terror in what she was able to accomplish," Freddie notes, a tone of awe in her voice even after these many decades. "And I like to think that, as her only daughter born under the American flag, I inherited her extraordinary get-up-and-go."

Freddie's feisty character was probably shaped as much by resistance as by example. Although Freddie adored her mother, mother and daughter were often in opposition. Journalism was one of their few compromises. Freddie had wanted to study medicine, perhaps inspired by her mother's midwifery. But the family could not finance six-plus years of study since they had already bankrolled the educations of the three older daughters, who all became teach-

ers—a career that maverick Frederica rejected. Agnessa insisted Freddie choose a career that could be achieved with a four-year college degree. Although Freddie had worked hard in high school to complete the Latin, chemistry, and science courses required for medical school, she decided on journalism because of her love for English and writing.

While at Columbia University, Freddie worked as a copygirl for the *New York Globe*—possibly the first female to hold that job at that newspaper. During that time, the competing *New York Daily News* was started. To gain readership, the new paper sponsored a short story contest, and Freddie won the one-hundred-dollar prize. "My impressed colleagues carried me around the office on their shoulders and hailed me as Miss Chekhov of 1918!" Freddie recalls. "But at the Sagor domicile, my literary success elicited outrage that I could have lowered my standards so far as to appear in print in a rag like the *Daily News*!

"I only had six months to go before I graduated from Columbia, but I was so bored with journalism that when I saw an advertisement in the paper in 1919 for an assistant to the story editor at Universal Pictures in their New York office, I was sure that it was going to be more interesting. Usually you need the degree to get any kind of a good job. But, I also would advise anyone to get a job while still at the university in order to learn something about the practical world," Freddie states, then frankly adds: "Of course, I was lucky that I got a job without a degree."

The movie business was a new realm for Freddie, who says with a hint of pride: "I came from a rather exclusive family and I didn't go to the nickelodeons, as they were called in those days. I only saw special shows like *Birth of a Nation*." With her new job, this soon changed. "I learned to write scripts by watching all the movies that came along," she explains. "My boss accompanied me at first, explaining camera shots and techniques of telling a story economically and dramatically. I might see a good picture three or four times, analyzing it, making stenographic notes of sequences, frame by frame. That was the way I learned screenwriting. I also went to every play on- and off-Broadway to look for good stories to adapt for film, and read all the new short stories and novels."

In less than four years, at age twenty-three, she was promoted to story editor. She continued to review plays and novels, now with the authority to acquire material for the studio. But what Freddie really wanted was to be a full-time screenwriter, and she extracted a promise from her superiors that

"One did not lightly challenge authority in the movie business, and I had been too cocky, too sure of myself."

she would be transferred to Hollywood to do just that if she succeeded in the story editor's job for one year.

Her big break resulted indirectly from purchasing the rights to a new novel, for which she hoped she would be given the chance to write the screenplay. "I knew immediately that *The Plastic Age* would be a bestseller, a hot property, and I had the precious galleys before any other picture company knew of its existence," Freddie says, recalling her reaction to reading the manuscript of the new novel by college professor Percy Marks. Unfortunately, Universal Pictures executive Carl Laemmle was convinced that it was too risqué, and as the newly appointed head of the Clean Pictures Campaign, he vetoed Freddie's purchase of the book. Freddie then scored a coup by reselling the rights to a competing studio, Preferred Pictures, for forty thousand dollars—making a ten-thousand-dollar profit for Universal. But Carl Laemmle, according to Freddie, "neither thanked me, nor in any other way acknowledged appreciation for what I'd done." This was an omen of what Freddie should expect from the film industry, but she was too enthusiastic and idealistic then to imagine the disappointments ahead.

When her bosses at Universal failed to honor their promise to send her to Hollywood, Freddie quit. Six months later, when she arrived in Hollywood on her own, she immediately called Preferred Pictures. The script for *The Plastic Age* had been forming in her mind. The project had not yet been assigned, and Freddie's career was launched with the contract to write the script for this silent film classic starring Clara Bow.

Life seemed easy; this first contract led to another for three years at MGM. But Freddie soon learned the lessons of studio politics the hard way. "One did not lightly challenge authority in the movie business, and I had been too cocky, too sure of myself," Freddie states in retrospect. Her three-year contract was canceled after only one year, and many of her scripts were credited to other writers. Eventually, contracts with other studios—Fox, Tiffany, Paramount—did materialize, and she contributed to or wrote dozens of successful films, silent and "talkies," including *Dance Madness,* and *The Waning Sex* starring Norma Shearer, *Flesh and the Devil* starring Greta Garbo, and her final film written with her husband in 1940, *The Shocking Miss Pilgrim* starring Betty Grable. But, Freddie was continually at odds with the Hollywood system.

Freddie recounts her days in Hollywood in her autobiography, *The Shocking Miss Pilgrim: A Writer in Early Hollywood,* penned after a hiatus from writing of more than forty years, during which she worked in the insurance business. The book, a scathing review of Hollywood from the late '20s

through the '50s, is rich in detail and sarcasm. Freddie describes numerous film industry soirees in intimate detail—including the chic outfits she wore for each occasion.

Proud of her fashion sense, Freddie tells of helping a young starlet, Lucille LeSueure, who arrived at the studio looking, according to Freddie, like "an obvious strumpet—a gum-chewing dame, heavily made-up, skirts up to her belly button, wildly frizzy hair." After a week at the studio, this new star-to-be approached Freddie for help. Freddie recalls, "She told me, 'They've given me a new name. From now on I'm gonna be Joan Crawford. And I was thinkin' I oughta change my image. I like the way you dress—like a lady. I figure you could help me.' So, how could I turn her down? The next day was Saturday and I took her shopping. Trying on those new clothes in the stores, the image in the mirror bespoke a new personality—a per-sonal-ity you could not ignore."

With the publication of her autobiogra-phy in 1999 and her one-hundredth birthday a year later, Freddie has been crisscrossing the country speaking and signing books. Whether before a television audience or sitting in her apartment in a Southern California retirement facility with her niece and nephew by her side, Freddie is equally frank and engaging. She is willing to discuss the gamut of topics from politics, religion, money, and sex to ethics and advice for a successful marriage.

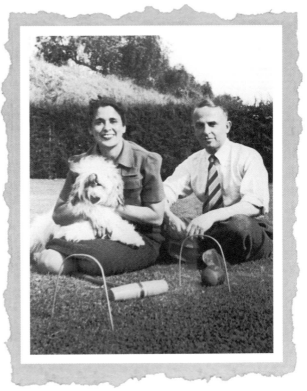

Freddie and Ernest Maas, circa 1945

"I was very casual about sex," Freddie admits. "When I was young I had no education, no discussion of it at home. I didn't know what it was really about. When I went out into the arena, there it was confronting me. There were few restraints in Hollywood about sleeping around. It was in the air, like a contagious disease. Since I had learned about the good old pessary, I felt free to play the field. When I felt like having sex, I had sex. But handsome, vain men, particularly actors, did not appeal to me. Men of accomplishment did."

One of those very accomplished men, Ernest Maas, a fellow writer and a producer with his own documentary film company, captured Frederica's heart. Ernest and Freddie, married by a judge on August 5, 1927, were part-ners in life and work for fifty-nine years until his death from Parkinson's

disease in 1986. Freddie feels that mutual respect and achieving a balance between their personalities was the key to their marriage, which never succumbed to the perils of Hollywood.

"I had enough respect for him and his mind to know that I had to temper my ways. No more freedom like I had before. If I wanted to continue having him as part of my life, I had to learn to behave. I couldn't always get my own way and only think of my own needs," Freddie says, referring both to her stubborn, strong will and her personal freedom. She adds, "Also, I never looked at another man. I knew I couldn't because if I did, I'd lose him. And that was a subtle factor in our marriage, because he was the same type—he had many women interested in him; he was a very attractive man. I had to change my behavior considerably, because here I was—a good-looking dame, and I had the world at my feet, and I could do anything I liked. And I married a man who was the same. We both changed because we knew we were complete to one another.

"'They've given me a new name. From now on I'm gonna be Joan Crawford. And I was thinkin' I oughta change my image. I like the way you dress—like a lady. I figure you could help me.'"

"I'm not very sentimental," Freddie says frankly, "but I do know that we were very good together. Ernest and I were very creative; he was more creative than I was. We were never looking for glamour. Creativity was our motivation. If you believe in yourself and you create something good, which is usually the hardest kind of thing to sell, you get a certain amount of satisfaction out of that."

Eventually, creative satisfaction wore thin and Freddie and Ernest became disillusioned with Hollywood. They had struggled against studio politics; through the Great Depression, when they moved back to New York City and supported themselves as theater and book critics; and against the blackballing of the McCarthy era, when they were shunned because of their socially conscious politics and their family ties to Russia. When they couldn't get work, they dedicated themselves to writing high-quality scripts together on speculation, hoping they could sell them later—but never did.

"We just got disgusted with the stupidity of Hollywood," Freddie reflects, a touch of melancholy in her voice. "I was fifty; Ernest was fifty-nine. We were washed up in the picture business. You can't easily start a second career at those ages."

Despondent at the bleak outlook for the future and from the recent deaths of both their mothers, the couple planned their mutual suicides. "We arranged our affairs, wrote appropriate letters, and picked the spot." Freddie describes how they sat in their car, ready to end it all. "When the last rays

of the sun disappeared, we calmly rolled up the windows of our Plymouth. This was to be our last sunset. The final step was to turn on the ignition. Next thing we knew, we were clutching at each other in a frightened embrace and sobbing. What were we doing? Failure, disappointments, lack of money, humiliation—none of these things mattered. We had each other, and we were alive."

They quit the film industry and never looked back. Freddie worked in insurance and Ernest did ghostwriting. In retrospect Freddie says, "If I had it to do all over again, I would never go into the motion picture business. None of our best work ever saw the light of day."

What Freddie is most proud of is the way that she and Ernest lived their lives—"with integrity and humanity." A dramatic example of their compassion was organizing aid for homeless and unemployed families during the Depression in the winter in New York City. "Almost directly facing our window, we could see a colony of homeless people along the Hudson River. Shelters were constructed out of cardboard boxes," Freddie recalls, describing a scene that has become familiar today, too. "These were not beggars; they were decent people out of work. They created a small community and shared food and such. Ernest and I soon visited the camp often, and before I knew it I was involved. I contacted restaurants and big markets to give us their discards. I even prevailed upon two local doctors to make visits."

Freddie sighs and, as if seeing one hundred years in perspective of a few basic principles, she reflects, "I've never believed in organized religion. I believe in humanity. You have to be decent to those around you and those you deal with in your enterprises, and be decent in your thoughts. You have to be a nice person. Character is very important. Most people are nice and decent and want to do the right thing—and most people do succeed in being decent and not being swayed by greed or ego."

"I do believe in evil," Freddie cautions. "From what I've perceived in my one hundred years, evil knows no barriers. There are awful things that have happened. Take Hitler for one. Who could have imagined that a human being could come up in a supposedly civilized world and do what he did? And the Catholic Church and a lot of other good people looked the other way. It happened in the twentieth century, so don't think it's never going to happen in the twenty-first. It's important to realize that people have the choice between good and evil. We all need to encourage ourselves and others to make the choice for good and decency."

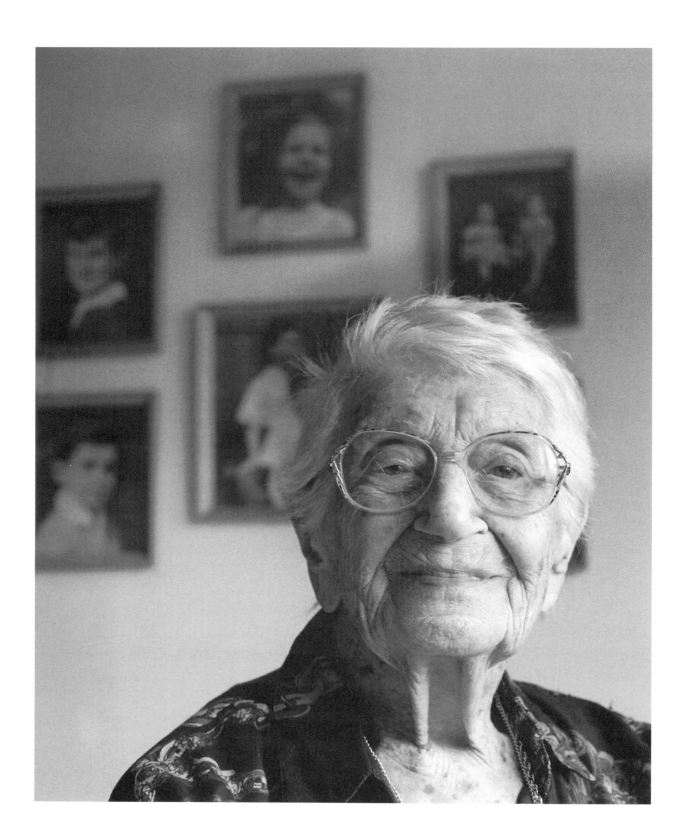

Lucille Diamond

BORN SEPTEMBER 11, 1899

Navy Veteran and Community Volunteer—Lucille was born in
New London, Connecticut. She joined the Navy in her hometown and served
for the duration of World War I. She later worked as the secretary to the president
of the Packard Motor Car Company.

"PEOPLE ALWAYS THINK it sounds strange that I married my step-brother. Isn't that something!" Lucille Diamond chuckles.

Lucille's mother, Fanny Greenberg, a widow with three small daughters, was introduced by mutual cousins to Hyman Diamond, a widower with two sons and a daughter. The matchmaking was a success and the two families merged into one big happy clan.

"We all got along so well that I really don't remember any fighting between any of us. We lived in such harmony," Lucille shrugs. "It seemed a natural thing; we didn't analyze it."

Lucille does remember that the family was very poor and that rural Connecticut life was harsh. "When I was little, we did not have hot water in our house, and in the winter we would put snow in a big pot on the stove and heat it for baths," she recalls. "We didn't have things like kids do today. We didn't go to the store for toys or treats; we made our own. I remember, in the winter we would take the snow and mix it with sugar for a treat— like a snow cone today."

Lucille's new stepbrother and future husband, Edward, born in 1891, was the oldest child of the group. So he quit school after the eighth grade, shortly after his father's remarriage, to help support the combined family. "He was so good to the whole family," Lucille says.

Lucille was able to complete high school and then secretarial school before the advent of the First World War. Edward enlisted early and was serving in France. Their hometown, New London, Connecticut, was a Navy town, and everyone was involved in the war effort. Since so many of the male sailors staffing the base were sent overseas, many of the local young women enlisted to fill the gaps.

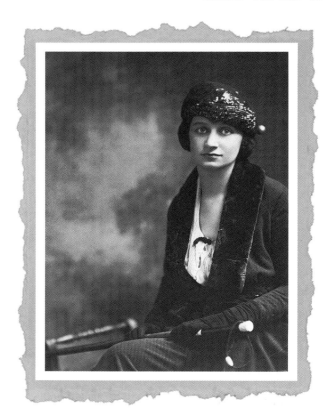

Lucille, circa 1920

Soon, Yeoman Greenberg was putting her office skills to use for the U.S. Navy. "I had to take exams and everything to get into the Navy, but I was able to live at home," she recalls.

After the war, Lucille went to Washington, D.C., where she held various secretarial jobs, including working for the president of the Packard Motor Car Company. She would return to the New London family home for holidays. Edward was now home from the war, and began to take notice of his younger stepsister.

"We began to fall in love, more than brother and sister. I had known him so long, and, of course, knew all about his family. I knew that he would be a good husband and father," Lucille says. The couple married in 1922, and he passed away in 1963. They raised two sons, Donald and Neil, and a daughter, Lois.

Edward and Lucille and their children lived in Brooklyn, where he owned a successful automobile service station.

World War II and gasoline rationing changed everything. "My husband wanted to enlist in the Army, but he was too old—already over fifty. He was very patriotic," Lucille states. "He wanted to support the war because our two sons were in the war. Donald was in the Battle of the Buldge and Neil was on a ship in the Pacific. So, Edward sold his business and went to work in New Jersey at a defense plant."

Lucille, who had been a full-time homemaker, dusted off her office skills to once again support a war effort. "I took a job at the Office of Dependents

Benefits, sending out checks to the families of servicemen. The Red Cross was also in that building," she recalls. "Sometimes I would volunteer to call on families of servicemen who had been killed. I would try to console them. I would bring some food, cookies I'd baked or something like that.

"I used to tell my children that to be a good person you must always be kind and honest, and I always tried to set an example. Well, one time I was in New York for some reason, and my son was with me. I think it must have been during the Depression because there was a man sitting on the sidewalk selling pencils. My son wanted one, but I told him we didn't need it now; we had some at home." Lucille explains that later, seated on the subway, she noticed her son holding a pencil. "I took him all the way back to that man and made my son return it."

Lucille's desire to lead a good life caused her to search for deeper spiritual fulfillment than she found in her Jewish heritage. Her personal quest brought her to study Christian Science. "I became a Christian Scientist in the 1930s. I had a friend, who was also a Jewish woman, who had become a Christian Scientist, and she told me about this religion. It just appealed to me. It gave me something to hold onto," Lucille explains. "It tells you to think in a positive way and to know that you are created perfect. Everything from God is created perfect. That is a way of thinking that I can live with, and it inspires you to help others.

"After the Second World War, I was a member of the Better Human Relations Council of the Oranges. This was a group that was working to improve race relations. We were all so anxious to make things better in the world," she recalls, remembering how New Jersey communities weren't truly integrated.

Lucille continued her volunteer activities at an age when many people might not have the energy. But being with people and helping people are what recharged Lucille's batteries. "When I was in my eighties, I volunteered to deliver Meals-on-Wheels to ill and elderly people. I just loved it, loved visiting the people. I did it for many, many years. Now, I get meals from that program," she smiles, appreciating that her good work is being reciprocated.

Like many centenarians, Lucille says that the hardest part of getting older is not being able to be with her friends. "Many of my friends have either moved away or have died," she laments.

In reflecting on how she has achieved her longevity, Lucille says, "By living day by day, and doing the right thing. And by being helpful. It is very important to help other people."

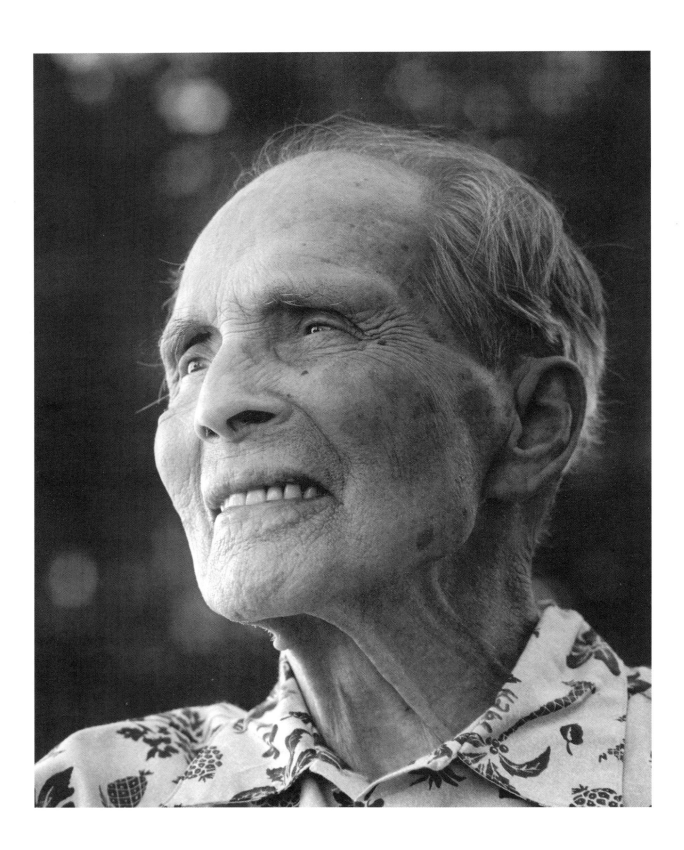

Jose "Joe" Flores

BORN JUNE 12, 1898

Chef and World War II Veteran—Joe was born in Calpan, Mindoro, Philippines.
He worked in Hollywood as a houseboy and chauffeur for many stars, including the
Marx brothers. He served in the Navy during World War II and was part of
the escort group for MacArthur's famed return to the Philippines.

"IF YOU WANT to be happy in life, you should live a simple life," advises Jose Flores. He explains his philosophy further: "You don't ask for too much; just be happy with what you get. That's the way I'm happy with my life."

Ironically, this centenarian's life has been more complex than he admits. Jose—Joe to his friends and family—was born in rural Philippines. His father was a Spanish soldier sent to fight in the Spanish-American War—the war that made the Philippines a colony of the United States in 1898. His childhood was disrupted by political and social unrest, and he was shuffled from relative to relative. Joe attended school only sporadically, working for Pacific Commercial Company, an American agricultural export firm, and then on merchant ships along with an uncle. Joe and his uncle jumped ship in California when Joe was nineteen.

"When I worked for that Pacific Commercial Company, I was quite young, and I went to night school and learned English. When I came to California—I was almost twenty—I went to high school some. I did not

graduate." When he attended high school, near Sacramento, Joe says that being older than the rest of the students was not his main problem; racial differences were. "In those days, if you were a Filipino, you were persecuted.

"I got homesick. So when it was school vacation, I went to San Francisco to see my other uncle. It only took about two dollars to go to San Francisco on the train then. This uncle was in the Army, stationed at the Presidio. He had been in the Philippine Scouts working at the Panama Canal." Joe found San Francisco a more compatible community for a Filipino to live in. He found work in restaurants, and learned all aspects of that industry. "I worked here; I worked there. Whenever I'd go for a job, they pick me up right quick. Sometimes I'd have to learn the job, but I grabbed any job that I could get. It was very hard for Filipinos to get a job in those days," he says. There is no bitterness in his melodically accented voice, however, just a matter-of-fact tone, as if giving instructions for a recipe.

"I worked for the Marx brothers for many years, whenever they had a contract in Hollywood. They would come back and forth from New York."

Joe never let social prejudices undermine his self-image or confidence. Joe decided to seek his fortune in Hollywood. Portraits of Joe from that era show a young man with exotic good looks that might have given silent screen stars like Valentino competition, but Joe's talents were not to be exploited in front of the camera. "I tried to get a movie job, but I didn't have ability for acting, so I end up as a houseboy," he shrugs. Joe worked with many Hollywood stars as a houseboy, gardener, chauffeur, or took on whatever jobs were offered him.

"I worked for the Marx brothers for many years, whenever they had a contract in Hollywood. They would come back and forth from New York," Joe explains. "I was their houseboy and chauffeur."

Joe saw Hollywood in its heyday, from the inside. "Groucho was a wild one," Joe says, then describes the milieu of the time. "Sometimes he would come home in the middle of the night, with maybe one hundred people from a party or wherever they had been. He would wake me up, and I would have to go down to the grocery store and wake them up and buy food for one hundred people. Then I would start cooking. These parties went on for two or three days; these were wild parties.

"The Marx brothers came from Brooklyn, from working vaudeville, and they came out to California and got into the silent movies, slapstick. I would drive them down to Universal Studios to do the movies," Joe says, describing his brush with screen stardom. "They had to do one slapstick scene in com-

edy where they were throwing pancakes at each other. So, I had to cook the pancakes, the real thing. I made stacks and stacks of pancakes."

Joe also enjoyed some benefits of his connections. "Mrs. Marx, their mother, loved prize fighting. On Saturday nights, I drove her to Los Angeles to the auditorium—she was an addict for boxing. I would go inside, too; they paid my ticket. One of the best boxing matches was between a Filipino and an Italian, but I forget the names. There was good boxing in those days."

Joe also worked for other stars and took in some of the Hollywood scene on his own time. Dancing was one of his passions—and the way he met his wife, Alice. She was Swiss and working in Hollywood as a linguist, helping actors learn to speak clearly for the new "talkies."

"In those days it was illegal to marry a Filipino," Joe explains. In 1872 California had enacted a law barring marriage between "white persons and Negroes or mulattoes." The law was amended in 1901 and again in 1933 to eventually state: "All marriages of white persons with Negroes, Mongolians, members of the Malay race, or mulattoes are illegal and void." To avoid the question of ethnicity, Joe and Alice went to San Diego to be married at the courthouse. Due to the proximity to the Mexican border, it was likely that Jose Flores would have been mistaken for an Hispanic name and the marriage would not be challenged.

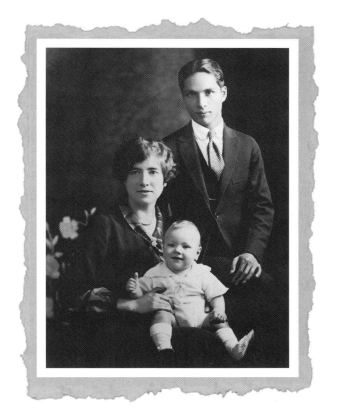

Jose, Alice, and Carlo, 1926

The couple's only child, a son they named Carlo, was born in September 1925. About three years later, the couple separated when Alice returned to Switzerland to visit her parents. "My Alice and Carlo could not come back," Joe says, "because the ocean was blockaded by the Germans."

But, other forces were at work as well. The couple were divorced in the Swiss courts. Joe, a devout Catholic, never remarried. Neither did Alice, who pursued a career as a concert pianist, which she had dropped when she came to America. Joe went to Switzerland once in the 1930s to see Carlo, but it wasn't until 1948 that father and son were reunited in the U.S. and forged a new relationship as friends.

As an American citizen by birth, Carlo served in the U.S. armed forces

during World War II, and then, seeking broader opportunities for education and business, settled in California and contacted his father. Carlo eventually brought his mother to California, where she lived the remainder of her life. But this was not an attempt to reunite the couple, who by then had gone very separate ways. Today Joe enjoys the affections of his son and daughter-in-law and an extended family that includes four grandchildren and four great-grandchildren.

"I tell my grandchildren and great-grandchildren to go to school and finish college, so they can get a good job. Because when I was young, I didn't have a good job."

After his wife and son left, Joe moved back to Northern California, again working in the restaurant business. But his career took a detour with the U.S. entry into World War II. "I had become an American citizen about ten years before the war, so I wanted to have a chance to serve my country," Joe states. "I went to enlist in the Army, and they said that forty-four was too old. So the next day I went up to Treasure Island, to the Navy, and I told them I was thirty-nine, and they took me." Joe's skills were put to use immediately. "So they put me in the galley right away, because they need cooks. But," he says, "they had their own way of cooking—everything is the Navy Way. That's what they taught me."

Eventually, Joe was assigned duty on a destroyer in the South Pacific. He would soon see his home territory. "I went back to the Philippines in a 'tin can,' and bombarded the Japanese. And then MacArthur came in at Leyte and all the ships lined up to protect him, and I saw his landing," Joe says, recalling October 1944, when MacArthur fulfilled his promise to return to the archipelago. Although he never went ashore, Joe says in retrospect that he is particularly proud to have served both his home country and his chosen country.

Joe doesn't say much more about his war experiences. "I know he must have been in some sea battles," Carlo says of his father's service, "because he has several medals of valor—bronze and silver stars. But he won't say anything about how he got them."

After the war, Joe returned to the restaurant business and remained active in the Navy Reserves. He would go to sea annually, and traveled the world. One tour was a goodwill tour through South America, and other trips took him to Asia and the Pacific. He stayed in the Navy Reserves until age seventy-five, when authorities realized that he had lied about his age at his enlistment and was now five years past the mandatory retirement age. Joe lived in his

own home until just past his one-hundredth birthday, and drove his car until his insurance was canceled when he was in his nineties. Today, Joe lives in a retirement facility run by the California Veterans Administration—and calls his new home "the country club."

Although he has no regrets, he does have some advice based on his experience. "I tell my grandchildren and great-grandchildren to go to school and finish college, so they can get a good job. Because when I was young, I didn't have a good job. Well, I loved my job because that was all I could do. I did all right for myself. But times are different, and it takes a lot of schooling to get a good job."

Her voice, clear and strong, still trembles with emotion as she recalls this life-changing event of so long ago, "My mother, my three brothers, and I sat in the front of the store waiting for my father. Finally, after what seemed forever, we could see his wagon coming, but he wasn't driving. My mother became very upset. She knew that something was wrong and whispered, 'I'm afraid something bad has happened to your father!' Then his employee told us that my father was killed crossing the street—a pole fell on him. It was terrible."

The earthquake hit at 5:13 A.M. and shook for more than a minute. If the Richter scale had been invented, it is estimated that this quake would have registered between 7.9 and 8.3. When the shaking stopped, much of San Francisco was devastated. More than two thousand people died, and more than twenty-eight thousand buildings and 2,593 acres lay in ruin. The ensuing fire burned for three terrifying days.

The military was called upon to provide aid and keep order. Cora remembers soldiers coming through her neighborhood: "The militia came and told everybody to stay out of their houses and to go up to the park on the hill at Steiner and Clay Streets. We had to sleep outdoors; the Army came and threw us all blankets. Those blankets were darn handy because it got really cold during the night.

"From the park, we could see the whole city burning. . . . At night the sky was full of glowing ashes. It's a wonder we didn't catch on fire, too."

"Thank God we weren't near the fire," she continues. "The fire was down on Van Ness Avenue and we lived on Fillmore, which is only about seven blocks away. From the park, we could see the whole city burning. Everybody was scared, especially when ash blew over us. At night the sky was full of glowing ashes. It's a wonder we didn't catch on fire, too."

All over the city, displaced people were directed to the Army base for food and shelter. Cora recalls her mother leading their family: "The next day we walked down Steiner Street to the Presidio for food. We had quite a walk. My mother had us kids and my father's brother, who was blind, to hold onto. You had to get in line for everything. The Army had set up rows and rows of tents in the Presidio. We walked down one aisle and another, but all the tents were taken. So we kept on walking. We slept under a wagon that night."

Another event soon split up the family: "My little brother, who was only four, had the measles, and somebody reported him. So the authorities came and took him away to the hospital; they had to keep him separate and we couldn't get him back for several weeks. They really took good care of him, but my mother was heartbroken when they took him away." You sense

that having her close playmate snatched away was equally distressing for Cora; at every turn, the world was in turmoil for this six-year-old.

When the family returned to their home after the likelihood of another earthquake diminished, Cora realized that her life would change dramatically. They moved from their flat above the store. "We didn't want to stay there," she states. "My mother had to close the store, sell out. Then she had to go out and work. She got twenty-five cents an hour cleaning houses and washing clothes for people."

For a widow raising four children, making ends meet was difficult on this small pay. However, Cora's memory spotlights the good times. In her typically optimistic way, Cora reflects, "Everybody was so good to my mother because they knew that she was alone."

Cora seems to see a good side to everything, a trait that may have helped her maintain good health and her bright, lively spirit for one hundred years. While some might see accepting handouts as a comedown in status, Cora remembers these as welcomed acts of kindness. "My mother had a customer who had two daughters, and their old clothes just fit me. She'd come home with these lovely dresses and, oh boy, I was thrilled. They were darling. I wore them for a long time."

Cora, circa 1922

Family helped out, too, as Cora recalls. "One of my father's brothers had a fruit store in North Beach, in the Italian area. He was very good to my mother. He'd come out to see us and he'd always bring a big sack of vegetables from his store. And, once in a while we'd find a chicken in there—he'd wrap it up and put it in among the vegetables. So, you see, everybody was good to my mother."

Cora also fondly recalls many fun times before her father died. "On Sundays, my mother and father would take the wagon that they delivered in and put us kids in the back, and we'd go up to Presidio Avenue and out to the beach. At one time they had a train that went all along the edge; you could look down at the ocean and see the beaches.

Later, Sutro Baths became a destination for her and her brothers. "I used to love Sutro Baths. I would take the streetcar there. They had lots of pools—

hot, medium warm, and cold. The guys used to love to show off and dive in there. I used to love to swim there; I was a darn good swimmer," she states proudly. "I used to go up to the Russian River and swim right across with some of the older guys." Swimming has remained a form of exercise for Cora, keeping her limber. She still swims in the pool at her seniors' community.

Cora's mother instilled in her children the value of getting an education. "My mother saw that we all finished high school," she states, alluding to the fact that many of her contemporaries left school after the eighth grade. "I learned bookkeeping at Commerce High. With the system that they had, they trained you like you were running a business. I learned so much. I loved to do bookkeeping. I always liked figures."

After Cora graduated, her skills got her a job in the financial district of San Francisco. She remained employed during the Great Depression, after she was married, and until she became a mother in 1933. "I worked in the insurance business, doing bookkeeping. I had a darn good job in those days. I made $250 a month, and that was really something," she says with a slight grin.

"I worked in the insurance business, doing bookkeeping. I had a darn good job in those days. I made $250 a month, and that was really something."

As a career girl, Cora shared a flat with one of her brothers. "My brother and I split the rent—I think it was fifty dollars each. My brother had a flower shop, Prenelli's Flower Land, on Clement Street. Our mother lived in the flat above the flower shop."

The family's social life included music and dancing—often at church functions. People created their own entertainment. Music plays a part in many of Cora's fondest memories. "When I was a little girl, my mother used to go out to the country to pick hops and at night we would have a big bonfire, and I used to sing. I used to love to entertain. I was a nut, really. It was kind of fun," Cora recalls. Her love of music and dancing continues. "I went dancing last night and it was a lot of fun," she says, referring to one of the regular social events at the community center in her development.

"Dancing was how I met my husband. I was at an Italian restaurant with a couple of girls from my office. The restaurant had a good orchestra and they were playing such good dance music. There was a table of boys near us. The maître d' came over and said, 'Would you girls be interested in dancing?' And I said, 'We'd love it.' So over came the boys. Of course my future husband, Arthur, didn't realize that I was Italian because I was blond with blue eyes. When we started walking out to the dance floor, Arthur says in Italian to his friend, 'Weren't we lucky to find these good-looking girls.' And I turned around and said in Italian, 'You'd better not talk Italian because I'll understand

what you're saying.' When we were dancing, he asked me to go to a party the next week. That's how it started, how we started going together.

"We loved to dance. We always had music around. I loved to sing. Arthur played the accordion—he was a darn good player. When he was young, before we were married, he even went back East and was on the stage. We would put on shows with everyone at the church. We had a lot of good times. We were married in 1931, and he passed away in 1984—fifty-three years. I'm very lucky."

Arthur owned a fruit store, which provided a comfortable life for the family that soon grew to include twin daughters, Barbara and Beverly. Cora has fond memories of their home. "My mother-in-law had two sons and she made the boys each buy a house before they were even married. My husband bought one and his brother bought the one next door, so we were neighbors. The houses are still there. We lived on Thirty-ninth Avenue between Geary and Anza. I was in the same house for twenty-six years until we moved out of the city. Our girls went to school out there and our church was around the corner. We had a very nice yard. We had a carpenter come and build a playhouse for the girls."

Cora's life centered around homemaking, family, and church. In homemaking, Cora found ways to express her creativity. She sewed matching outfits for her girls, crafted costumes for church plays, and made her own clothes in the latest fashion. A row of framed photographs of identically dressed twin girls, progressing in age, lines the wall of the hallway in Cora's modest home.

Cora is still interested in fashion, and takes pride in her appearance, making sure her hair and make-up are done just so. And she still does needlework. "I go every Tuesday to my sewing group—three or four of us girls go every week," she explains. "We make lap robes and give them out to the convalescent homes. It takes quite a while to make one because they are all quilt squares. We get the nicest thank-you letters."

Although she stopped driving in her nineties, Cora has remained active in the community thanks to a support system of her daughters and family and a live-in companion/aide.

In reflecting on her long life, Cora doesn't know why she's lived so long, although she acknowledges that genetics may play a part. "My mother lived until she was ninety," she states. Although she is still active—she still swims and goes dancing—Cora doesn't give herself credit for her longevity. "I've just been darn lucky," she says. "I've had good health and I feel pretty darn good."

When asked what advice she gives her nine grandchildren and eight great-grandchildren, Cora smiles, "Just make sure you have fun and are happy."

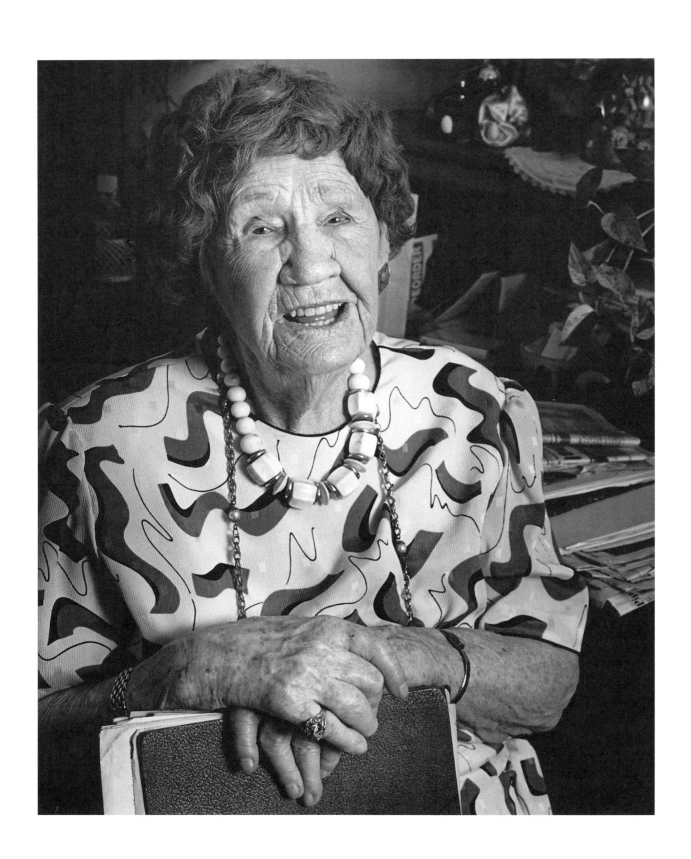

RUTH HAMILTON

BORN APRIL 12, 1898

*Teacher, Businesswoman, and Legislator—Born in Alta, Iowa, Ruth was a teacher,
owned several successful small businesses, traveled the world, and was elected twice
to the New Hampshire legislature. Her husband pitched for the World Champion
Cleveland Indians, before becoming a doctor.*

"I DON'T THINK I'VE had any dull moments. Every desire I ever had, I
fulfilled. That's what a wonderful life I have," gushes Ruth Hamilton.
"I'm a dare person. Dare me and I'll do it."

And she has. This remarkable centenarian has been a teacher, business
owner, state legislator, wife and mother, and world traveler.

Right from the beginning, it was obvious that Ruth was full of vim and
vigor. "I was born at high noon, when the whistles were blowing and the
express train was coming through, and Mama was yelling and I was squeal-
ing," Ruth says. "I was so lively that I wiggled to the bottom of the bed.
Mama said to the nurse, 'I wonder what's going to become of this child?'"

The only daughter of a Danish father and Swedish mother, Ruth Karen
Marian Jensen grew up in the farming community of Alta, Iowa, and didn't
venture away until after she graduated from high school and went to Iowa
State Teachers College. "At that time, they needed teachers so badly in the
country schools that they had crash courses," Ruth recalls. "We could get the

two years of training that was needed for a teaching certificate in twelve weeks, but we had to go to school night and day to do it."

Ruth began teaching back in her hometown, in a one-room country schoolhouse. "I didn't have all eight grades," she recalls. "I had the first, second, fourth, and eighth grades. All the kids could hear all of the recitations. It was fascinating. I think all the kids benefited; the younger kids learned faster and the older ones had to explain everything much more clearly. So it was a good system."

With her teaching career underway, Ruth's natural curiosity and sense of adventure began to assert themselves. "I would pass by this building with big windows, and I could see big wings spread out and it smelled like bananas," Ruth says, chuckling as she recalls her first encounter with airplanes. "So I got interested and went in to see what they were doing. They said they were making airplanes and that the smell was banana oil, which they put on wings of the planes to strengthen them."

"Married women couldn't teach," Ruth explains. "So, I kept it a secret and wore my ring on a chain around me neck."

Ruth soon became friends with the owners of this business. "Pat Willis and his pal, Casey Jones, were just back from the First World War. They had been pilots, so they started their own airplane factory, making their planes by hand. Pat really liked me, and to impress me he gave me a ride. One day he said, 'Ruth, I have to deliver a plane to the Maytag people.' (They made the washing machines.) 'I have to fly it to Des Moines. Do you want a ride?'"

This was a dare Ruth could not resist. "I got a helmet, a leather jacket, and goggles. I got in the back seat of his plane and fastened a big safety belt. Well, that ride pretty near scared the life out of me. Pat turned the plane and almost tipped it over. Oh, I yelled bloody murder. I was scared pink. I thought I'd die before I got to Des Moines."

On July 5, 1920, romance struck. Ruth recalls the day. "It was at a sandlot ballpark in a small Iowa town. The town's celebration of the Fourth of July was on the fifth because it had rained on the holiday. I was visiting with a friend and one of her friends came over and introduced himself. He was a college man, and he said to me, 'Look out at center field. That guy out there is visiting me; he's a classmate and captain of the Iowa University baseball team. Would you like me to introduce you?' So, Carter Hamilton and I got acquainted that day and we fell desperately in love. We went together for eight months before we got married."

Their wedding was an impromptu trip to city hall. "Carter got farmed out to the Cleveland Indians, the big leagues, and he came to say good-

bye. He was going to go to see his parents the next day. He said, 'I'd like you to come with me, but I know your mama won't let you unless we're married. So let's get married.'" Not one to let a good offer pass her by, Ruth found a substitute teacher and took half of the next day off. "On April 21, 1921, we went to Des Moines and got married," Ruth says with a smile.

Their marriage could have meant the end of Ruth's teaching career. "Married women couldn't teach," Ruth explains. "So, I kept it a secret and wore my ring on a chain around my neck. But, I was touching and kissing it all the time. Well, my kids saw this, and they told the other teachers. So I had to confess. Then I had to go to the school board. They said, 'We're not going to let you go. We're going to change the rules.'" This wasn't the first time Ruth would go against the grain.

Carter continued to play baseball during the summer and attend college, and later medical school, in the fall. Ruth continued teaching to support herself and her husband through his medical school, internship, and residency.

Once her husband became a doctor, and bought a practice in a small Iowa town from a physician who was retiring, Doctor Hamilton wanted his wife to stay at home. Ruth would have none of that.

Ruth's restlessness and constant curiosity soon led to world travel. Ruth's first overseas

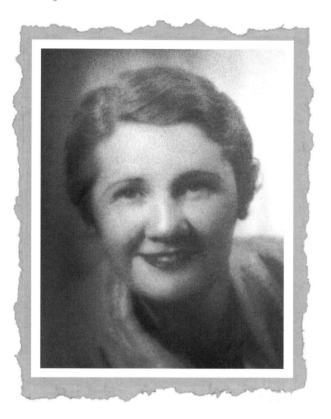

Ruth, date unknown

trip was in 1937. "One day I came home and I said to my family, 'I'm headed for Europe. I'm going over to discover who I am, to find my roots.' I had relatives in Denmark and I spoke both Danish and Swedish. My husband said, 'Well good, now I can go play golf and you won't bother me.' And you know, I went and was gone for about two months. It took about eight days to get over. I had a wonderful time on the ship. I met so many other travelers who had been to places I'd never even heard of. So that started my yen for travel. Then, every time I got some money, I bought a trip."

On this first trip, Ruth crossed paths with history in the making. "In Berlin, I saw all these women at this gate, and I thought 'What's going on here?' It was Hitler's chancellery, his White House. The crowd kept yelling, 'Heil Hitler! Heil Hitler!' As he was coming out, I stood right by the gates

and I could almost touch him—just a little guy with a mustache, but you could tell why they were mesmerized by him. Oh, he had charisma, power. You could feel it. One woman fainted—she was so happy that she couldn't get over it."

In addition to seeking her roots through travel, Ruth also sought fulfillment in motherhood. But for Ruth, becoming a mother required initiative and faith. "I went to a Thanksgiving Quaker Service, and I prayed during that whole service that I wouldn't have another Christmas without a child. I prayed, 'Dear God, give us a son. I don't care if he's pink or yellow or green, so long as he's a good boy.' Guess what? He was born Christmas morning."

Ruth explains how she found her son. "My hairdresser told me about this lady who was going to have a child—and she wasn't married, and it would be a disgrace. Well, I went to see her immediately, and I liked her instantly. I stayed with her until she had Peter.

"We moved to Philadelphia, where my husband was an X-ray specialist. He still didn't want me to work, but I got fidgety," Ruth says with a mischievous smile. "One day I was walking to the neighborhood grocery store, and I noticed an empty building. I stopped and looked inside and I thought, 'Oh golly, wouldn't this make a nice dress shop!' So, just that quick I went down to the real estate office, got the agent to show me the inside, and I immediately decided to buy the building. So, I went to the bank and got a loan. My husband could have killed that banker. I gave such a good talk, explaining how I could pay, and I did pay it back in a hurry."

Ruth then worked diligently to learn the retail fashion business. "I went down every Monday to the wholesale places. I didn't know a thing about merchandising; I learned it all the hard way. But, you should have seen the pretty clothes I found, and the shop became so successful. I had a darling shop—really adorable with antiques all over the place. I called it the Karen Shop, after my middle name.

"I had the shop for two years when a man came along and offered to buy the building. Well, I sold it and made two thousand dollars profit, which I immediately used to buy a log cabin on ten acres that I'd been wanting. My husband and I loved that cabin, so he decided the business hadn't been all bad."

Despite all their disagreements about Ruth working, Ruth sees their marriage as a true friendship and partnership. "It was a beautiful marriage," she recalls. "It wasn't vulgar like all that sex business you see on television now. That's all just lust. We were good friends and always helped each other. With us, things came naturally. He used to say to me, 'Nobody sleeps together as close as we do.' He would always hug me. He was a big man, six feet

and three inches tall, and so handsome. He died in 1948 at the age of fifty-one. Our son was only twelve. It took all my faith to keep going."

A deeply spiritual person, Ruth says, "God is everywhere. You don't have to get down on your knees or go to church. I talk to God all the time. Whenever I have something good to eat, I thank God for the hands that made the food possible—the farmer who planted and nurtured the seeds that grew into the vegetables, the people who gathered the crop, and the person who sold it—all of the hands the food goes through before it comes to my table. By the time I am through giving thanks, I am uplifted. That's what revives people. Gratitude is prayer."

After her husband's death, Ruth took refuge in her cabin, which was in New Hampshire, and was soon involved in local politics. However, before long, other business ventures and wanderlust pulled her away. She later returned to New Hampshire to live and was elected twice to the state legislature from 1964 to 1973.

Ruth recalls how she took up the dare to get involved. "The kids came to me and asked me to run; they wanted to get the vote for eighteen-year-olds. Well, I remember marching to get the vote for women, so I sympathized. So I became the kids' legislator. I also got inspections and licensing put in place for residential homes caring for senior citizens. Before my bill passed, anybody could take in senior citizens and charge anything they could get, and some of the places were dreadful."

For these efforts and more, in 1986 Ruth was recognized for her outstanding contributions to the state and honored as an "Unsung Heroine" by the Claremont New Hampshire Commission on the Status of Women.

Still a great supporter of young people, Ruth advises, "Get all the education you can. Learn anything you can. No matter what your age, keep learning. Put this motto on your mirror so that you'll see it: 'Every day without learning something is a day lost.'" And, as if she is presenting you with a dare, Ruth urges, "If you believe in something, stick with it. I just wish I could live to be one thousand years old because there are so many things that I want to see improved."

"The crowd kept yelling, 'Heil Hitler! Heil Hitler!' As he was coming out, I stood right by the gates and I could almost touch him—just a little guy with a mustache."

Earning a living was soon to be the least of Bernard's concerns as the effects of the First World War began to hit home. In a memoir of his life through World War I, which he wrote in 1923, Bernard states: "Life became more difficult. You started to see things you never thought you would see. Across from us was a hospital. I would see people brought in with no feet or with artificial limbs. There were also about five thousand Austrian prisoners." In describing Kiev during the war, he writes, "I knew one officer who had returned as an invalid because of the gas which the Germans used. I often sat and talked with him and discussed the war. He informed me what war is and how the fighting is waged. I forced myself to listen to all that he told."

This information would eventually be more useful than Bernard ever imagined. The war would soon engulf him. He writes: "In August 1916, they started calling up those who were born in 1897, and I was really frightened. Then in February 1917, I saw in the newspaper that those born in 1898 had to register and would probably be called up that year. I nearly fainted. I put my head between my hands and had a good cry."

Bernard left Kiev immediately and returned to his parents' home to hide from the draft. Despite several police raids resulting in the forcible conscription of more than one hundred youths from his area, Bernard successfully evaded the authorities. Bernard says, "I thought, 'I won't go to be killed, and truly for what cause should I go? As a Jew, I live my life without any privilege or opportunity.'"

Bernard's personal drama was being played against the backdrop of political unrest in Russia, as well as that of the world struggle. While Bernard avoided the military, the government of his country was in an internal conflict exacerbated by the external world conflict. During the first Pan-Russian Congress, in June 1917, two men dominated the debate as to whether or not to sign a separate peace with Austria. Minister of War Alexander Kerensky argued against, while Delegate V. I. Lenin favored conciliation, describing involvement in the war as "treason to the interests of international socialism." Unfortunately for Bernard's future, Kerensky's views prevailed and he became Premier of Russia in July 1917. Czar Nicholas and the royal family were imprisoned, and conversely, complete amnesty was granted to political and religious prisoners.

"Kerensky announced that anybody that had not joined the army should come forward. They would not be punished. He assured us that the war is

> *"A row of Cossacks surrounded us, so we could not run away, and we were loaded into trucks,"* Bernard's voice trembles, accentuating his heavy accent. *"When we got there, it was, I can't describe it. It was hell."*

going to end soon. So I went. I was trained to be a machine gunner. One night they announced, 'You have to go to the battlefront.' It was just after the big battle of Galicia, where so many got killed. They needed to fill out the numbers at the Austrian front. A row of Cossacks surrounded us, so we could not run away, and we were loaded into trucks," Bernard's voice trembles, accentuating his heavy accent. "When we got there, it was, I can't describe it. It was hell.

"You could see people falling right before your eyes. We immediately started digging trenches," he says. Bernard's memoir describes terror-filled battles; the uneasy waiting, retreating, and regrouping; the exchange of shooting and the bombing. "On the fifth day, around 3:00 in the morning, there was firing from both sides. One could hear a moan here and there, but it was dark and we could not see the dead—only when a rocket went off could we see around us for a few minutes. Suddenly, we heard that we should run away, as the Germans were taking over. At the same time that they called to us to go, the Germans were coming closer and closer, and constantly firing so that we could not move."

Bernard and a Russian officer hid in the home of a villager. Bernard's linguistic ability and quick wit came to their aid. "I told those people, 'Don't be afraid. We are not going to do anything to you. We are not Cossacks.' So, they let us hide. But the house was bombed, and in the morning when we got up, the Germans were coming in. We were told that the Germans don't take prisoners; they shoot them. So, I immediately found a dead German soldier and took off his clothes and changed into his uniform."

In disguise, Bernard dodged the Germans for several days before he was taken prisoner. He was sent to work in the forested area of Alsace-Lorraine, disputed provinces situated between Germany, Prussia, France, Belgium, Luxembourg, and Switzerland. For more than a year, Bernard cut lumber or harvested crops to fuel the German war effort. "We were always hungry," he says of the laborers. "After seven months in that camp, there were only 225 men left from the 500, the others having died of starvation. When we were returning from our daily work, we would always see someone drop to the ground."

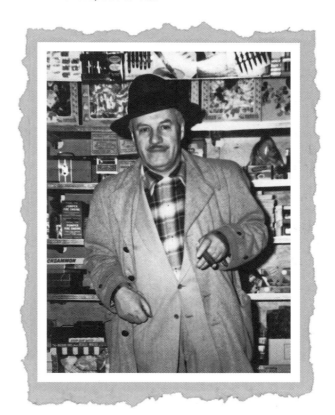

Bernard, circa 1930

Exhausted by hard labor and lack of food, Bernard devised a plan to ease his burden in the labor camp. "I decided that the way not to starve was to work in the kitchen. So, I convinced them that I was a cook. I had never done such work, but I quickly figured it out. I don't know how I did it, but I did well. And I was able to help some fellow-Jews by giving them extra bread that I took from the kitchen."

As the war began to turn against Germany, and the area was evacuated for hand over to the French, Bernard saw his opportunity for escape. He bribed a guard and acquired a German uniform. Then, over a period of months, alternating between his German army and prisoner-of-war uniforms, depending on the situation, he worked his way across Eastern Europe to his home.

"When I saw my town, I wept for joy," Bernard recalls. "It was about 6:00 in the morning. A man approached, carrying two pails of water from the well on his shoulders. When he recognized me, he started to yell, 'Baruch, Baruch,' using my Jewish name. And he let go of the pails and went running to tell everyone that I was not dead. When I got to my parents' house, it was already full of people. Everyone was hugging me."

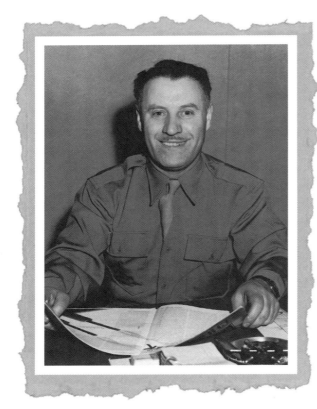

Bernard, circa 1943

But things were not good at home, he soon learned. He shakes his head, "All the time bands of Cossacks would make a pogrom—rob and kill people. I had to hide myself in my own house." But the most devastating enemy was an invisible one: disease. "My mother lay sick for eight weeks, and we could do nothing for her. The doctors came day and night, but couldn't help. She died of typhus." Bernard's voice quivers with these memories.

"During that time, some people arrived from America and took their relatives back with them. That's when I got the idea that I should leave for Canada. My older brother had gone there in 1910. I sat down and wrote him a letter, not knowing whether it would get there. Then I tried to make a plan of how I would leave. Little by little I made my preparations. I changed my Kerensky money; I gathered food," Bernard says. "I couldn't get to the border. They were fighting the Bolsheviks and the Germans, and you couldn't get across. Finally I got near the border and found work on a farm, and I got

acquainted with the border guards. I was bribing them, giving them cigarettes, everything. I finally got across and back to Hamburg."

His plan was to stow away on a ship. Every day he observed the docks and the arriving and departing ships. After one unsuccessful attempt, Bernard succeeded in getting on a ship to South America. When he was discovered aboard, the captain put him to work as a cook. Bernard made friends among the crew members and learned English. He finished the round-trip voyage, ending in Antwerp, Belgium. Bernard recalls the kindness shown him: "When I left the ship, the *Lore Scotland,* the captain gave me a nice blue suit, which he'd bought for sixty-five dollars in Philadelphia, and a new American-style cap."

His next attempt to stow away, on a ship to Canada, got him arrested. But this turned out to be his change in fortune because he was sent to a refugee camp in Holland. Bernard smiles, describing the happy ending to his ordeals. "They located my brother. And one day, I got a big package, a big letter with money and a ticket to the ship. So, I came to Canada like a regular passenger. I came to Quebec, and my brother was supposed to meet me there. He didn't know what I looked like. It was a very busy station and he couldn't find me. Finally, the next day he came again, and we found each other. We went to his place to live in Saskatchewan. It was October 20, 1920."

Bernard's brother owned retail dry goods stores. Working for him, Bernard sharpened his customer-service skills and business know-how. He immigrated to the United States in 1923 and started his own business, organizing sales and advertising for retail businesses, and married a Canadian woman. He became a U.S. citizen in the 1930s and, during World War II, served in the U.S. Army, running a post exchange in Michigan. In 1963, he moved to Los Angeles, where he had a wholesale and import business specializing in sunglasses. He retired at age eighty-five. Bernard has two daughters, seven grandchildren, and fourteen great-grandchildren.

"I had a stroke, but I'm better now. I exercise every day. I take good care of myself. I am my own doctor. I do what is necessary," he says, defensive at his family's suggestion that he needs more help than is available in his retirement complex.

"I never expected to live so long," Bernard laughs. "One day, I woke up and thought, 'Gee, I'm an old man and I didn't realize it.'"

FAITH GUTHRIE

BORN DECEMBER 10, 1899

Businesswoman—Born in Ottawa, Kansas, Faith Guthrie never wanted to be a teacher, so she attended business college. Today she and her family run one of the largest jukebox vending businesses in Southern California.

FAITH GUTHRIE LAUGHINGLY says that what she likes best about running her own company is "counting the cash receipts." This centenarian founder of G and G Amusement Company, says that the best perk of her job is her Lincoln Town Car, in which she drives herself to work on the Los Angeles freeways.

But, observing the attention she gives to the people around her, you know there is more to it than just money. Mrs. G., as she is fondly referred to by all, enjoys the sense of accomplishment that comes with starting a business from scratch and watching it grow and prosper. And she cherishes her employees as if they were her family. Many have been with the company for a decade or longer. The most senior worker, in age and employment, is eighty-three-year-old Jenny Bowie, who has been with the company for thirty-three years. Mrs. G. readily acknowledges the role of her loyal staff in making G and G Amusement one of the largest distributors of vending machines, games, and jukeboxes in Southern California. "Each person here

has a certain quality and skill that contributes to our success," she says, like a grandmother lauding her brood.

A hallmark of this family-run business is Mrs. G.'s grandmotherly interest in her employees. "They're all free to come in my door anytime. And I want to know about their families. One young man's had some family problems, so I can't go home without talking to him."

Mrs. G. went into business for herself in 1947 after her marriage ended in divorce. "I was just trying to make a living for myself and my fourteen-year-old son," she states modestly. She started out with a distribution route for the Los Angeles *Mirror News* and segued into vending machines and jukeboxes.

"Newspaper distribution suited me because I didn't want to be separated from my son. I did the route in the afternoon and kept him with me," she explains. At that time, newspapers were commonly sold on the street corners by paperboys to workers on their way to and from their jobs. It was Faith's task to hire the paperboys, pick them up after school, and drop them off on the corners. At the end of the evening commute, she would then pick up the boys and take them back to their neighborhood school. The boys were paid a percentage of each paper they sold. "The good part is," Mrs. G. smiles, "at the end of the day you always have cash, all cash."

Always on the lookout for business opportunities, Faith's interest was piqued when she saw a woman collecting the coins from a cigarette vending machine. "I had a long talk with her about vending machines and decided this was something I could do." Not being a smoker, Faith explains, "I tried to find a way to do candy machines, but couldn't locate any. Then I saw an ad in a newspaper for a small route of cigarette-vending machines for sale." The ad turned out to have been placed by the same woman Faith had met. Faith bought the small route, and in 1952 her vending business was started with the purchase of ten cigarette machines, including cigarettes and matches, for $1,203.17.

The timing turned out to be fortuitous. "I got into vending machines as a sideline. You were not supposed to have any other job when you worked with the *Mirror News,* so I did the machines at night. And then the *Times,* which owned the *Mirror News,* bought out the competing evening paper, the *Herald,* and they discontinued the *Mirror News,* so I was out of that job."

The original vending machines were located in gas stations and garages. As she bought more, the placements expanded to bars and nightclubs, which

"And I got the job. I conducted myself like a lady, I got respected as a lady."

brought a new vending opportunity—jukeboxes (which are now the company's mainstay)—and additional stigma.

"It was way out of my social sphere—not the way I was raised and everything. And my people were ashamed of me being in such an awful, crude, crummy business. But, what could I say?" Faith sighs. "I needed to make a living for myself and my son. This suited me because I could be with my son. And I could see there was money in it. It wasn't great big money at first, but eventually it turned out to be."

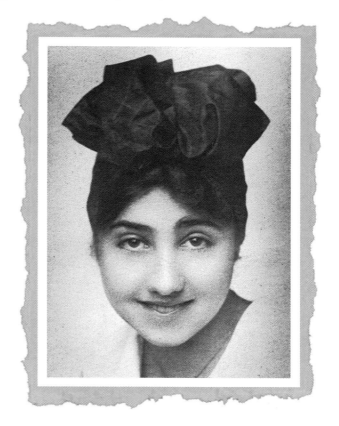

Faith, circa 1915

Mrs. G. takes pride in always being treated like a lady, despite the need to visit what she considers questionable locations. "I was not timid, but I felt inadequate to the job of making sales calls to some of these bars. So I was all the time bluffing, acting confident, and eventually it became easier. There were what they called 'topless bars.' I wanted a particular bar location, and I got the word that they wanted a new jukebox operator. Talk about psyching yourself up to go to that place. Fortunately, the owner met me at the door, and we didn't have to go where the dancing was in order to get to his office. But while we were talking, this girl came in. My back was to her, but she didn't have a top on. The owner said to her, 'You don't come in here without a top on. I have a lady here.' And I got the job. I conducted myself like a lady, I got respected as a lady."

Part of Faith's professional image is dressing in a business-like manner, always a nice suit or dress and her trademark high heels. Although those shoes are no longer her signature wardrobe item, she still carefully coordinates her dozens of flat shoes with her outfits. Today she wears lavender tailored pants, a matching silky lavender blouse, a contrasting purple jacket, and two-tone purple and lavender flats.

The business has provided a good living for Faith. Her son, John, was her partner in the business until his death at age sixty-three in 1994, from heart disease. Now her grandson, also named John, and his wife, Dana, co-manage the seventeen-employee firm with Faith.

Faith has always had an interest in business. "I didn't want to be a

teacher," Faith says emphatically. "When I was growing up, that was one profession that all ladies had if you were going to work outside of the home." So, after high school graduation, she attended a business college and then went to work for a bank in Twin Falls, Idaho, where her parents had moved when she was a youngster. Her big break came when the president of that bank went to work at the Federal Reserve Bank in Salt Lake City, Utah, and hired Faith to go with him.

Faith, circa 1922

"When I went to Salt Lake, my folks were so worried about me going to the big city. I didn't know a soul there. I stayed at the YWCA." She explains that she was not lonely for long, "Salt Lake was called the 'Crossroads of the Southwest' because it was a transfer station on the railroad. My friends would come through from home, which was about three hundred miles, and they'd want to take me out to dinner and out dancing. They had strict hours at the YW, and if you were going to be out past midnight, you had to let them know in advance and they would wait up for you. It got to where I was out every night, and they got sick of waiting up for me. They started calling me the 'Cinderella Girl.'" Faith looks back on this as the most fun time of her life.

After a year, Faith got wanderlust, and decided to join an aunt in Southern California in 1923. Here she was introduced to her husband, Walter, by a mutual friend. The couple married in 1927 and had one son. They remained good friends even after their divorce, which Faith says was because Walter had a drinking problem. However, Walter later joined her in the business and worked with her until he suffered a fatal heart attack.

"My husband was from a different upbringing than mine. His uncles and everybody were professionals and attorneys." There were cultural differences, as Faith explains, "My people were gentlemen farmers. My grandfather was a captain in the Confederate Army. He had plantations, colored slaves, and raised thoroughbred horses. When I was growing up in Kansas, you could probably say we were a little better off financially than most people. We always

had colored help. You didn't wash your clothes or iron your clothes where I lived. My mother had someone to do the cooking and cleaning. In Kansas we viewed black people as hired help—not your equals."

Walter's perspective was much different, and Faith says that he opened her eyes. "Once I made a comment of some kind, and he said, 'It doesn't reflect well on you to not show courtesy to everyone. You never want to be discourteous or think someone is beneath you. If they treat you with courtesy, you treat them back with courtesy.'" Faith says that she hadn't even realized that she might be perceived as rude or prejudiced because her upbringing had not taught her to consider the issue of racial equality. "That's when I realized everyone has excellent qualities, whatever their color or their stature in life. That was the turning point with me."

Faith's new outlook shaped her business philosophy. "I treat everyone with the same respect I want in return from them. I always believe you must conduct business with integrity. You must keep your word and have high principles. I want my customers to rely on us and I need to rely on my employees. Trust is the key to success. And paying attention to people, treating them right."

Mrs. G. is especially enjoying the attention she is receiving as a centenarian. But she doesn't take credit for this accomplishment. "I have a heritage of longevity. My mother lived to be ninety-six. My father was ninety-two when he died of pneumonia, or he would have lived longer." Then she adds with a wink, "I'm a great believer in miracles."

"I treat everyone with the same respect I want in return from them. . . . You must keep your word and have high principles."

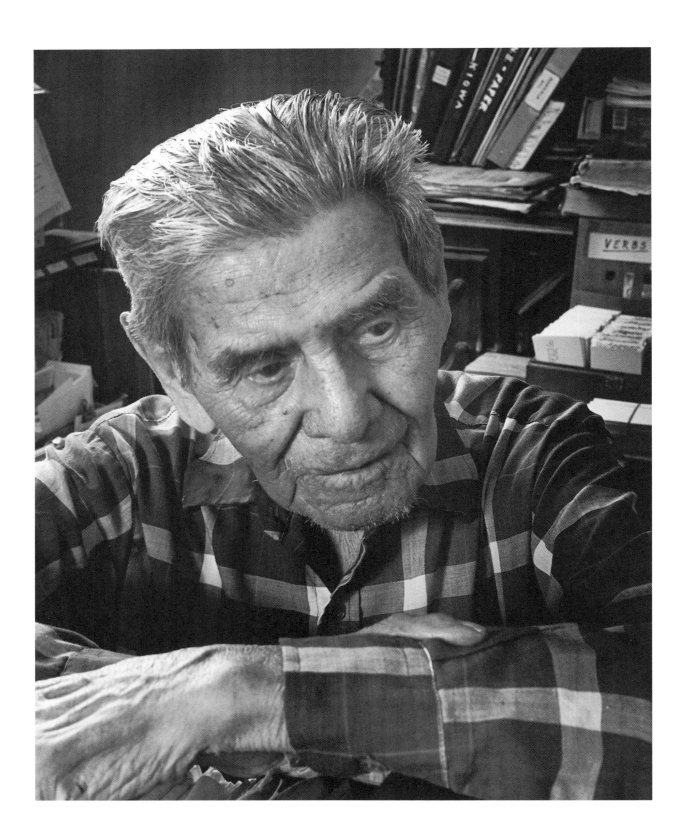

PARKER YIA-SOM McKENZIE

BORN NOVEMBER 15, 1897

Linguist and Oral Historian—Parker was born in a teepee near Rainy Mountain, Indian Territory. He worked for the Indian Agency almost thirty-nine years as a fiscal accounting clerk. Since age fourteen, he has been developing a system for writing his native Kiowa language.

"I'M THE ONLY living Kiowa who was born in the nineteenth century," states Parker McKenzie proudly.

He is the living history of his people. With his thick Oklahoma twang and speech cadence so slow that it is hard to tell where one word stops and the next starts—interspersed with Kiowa names and phrases—Parker spins a yarn that makes you feel you are riding along with his forefathers, *Queton* and *Yia-som,* as part of a Kiowa war party.

"My grandfather, Queton, was a Mexican boy who was taken captive by the Comanche and later traded to the Kiowa," says Parker, tracing his lineage. "He became a Kiowa warrior and made many forays with war parties into his mother country, now an area in Texas.

"I was given the Kiowa name of my great-grandfather, Yia-som, meaning 'twice looked at.' Twice he's supposed to have done something meritorious in battle that attracted the attention of his comrades," Parker explains.

"Yia-som was a prisoner of war, along with Chief Lone Wolf and twenty-five other Kiowas, for their crimes against the white people. They

were imprisoned in an old Spanish fort in Florida in 1875. Yia-som was involved in one of the last outbreaks the Kiowas perpetrated, along with the Comanches, in August 1874. They went on a rampage near Anadarko, Oklahoma—then called Indian Territory. They killed several people in that outbreak. There was a group of white men out making hay east of Anadarko, and my great-grandfather was with a group that killed those hay makers. But one farmer escaped and notified the Indian Agency of what had happened. Soldiers were sent from Fort Sill, which was established around 1859, and my grandfather and his band were captured."

The family name of McKenzie has an equally colorful story behind it. "My father was a white man who'd been captured by the Comanches as a child, then traded to the Kiowas. His name came from the commander at Fort Sill, General Ronald S. McKenzie. When this general fought in the Civil War, the thumb and half the pointer finger on his left hand were shot off. Dad also had his left thumb and half of his left pointer finger shot off from an

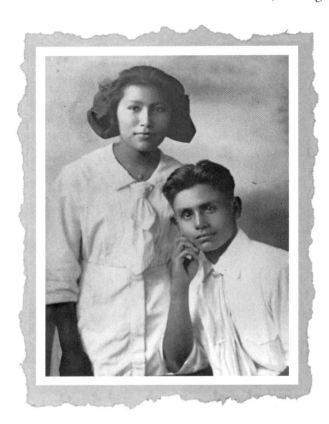

Parker and Nettie, high school sweethearts, 1917

accident as a child. The quick-eyed Kiowas saw the resemblance and began calling Dad 'General McKenzie.'

"My grandmother broke horses as a young woman and got hurt when she was thrown from a horse so she was partially crippled. Since she couldn't move about well when she got older, her mouth was almost always going, always telling stories," Parker chuckles. "In fact, I was my grandma's boy; I spent most of my childhood with my grandma right here on this farm. That's why I learned Kiowa very well. My grandmother was still alive when I had my first child. So she lived long enough that I got a lot of information about our history from her."

But Parker's invaluable contribution to his culture goes beyond his status as an oral historian. As a self-trained linguist, his avocation since age fourteen has been developing a system for writing his native Kiowa language. He has compiled 12,095 two-syllable words, and hasn't counted his list of words of three or more syllables.

To appreciate Parker's devotion to saving his native language, it is neces-

sary to know his school background. "I enrolled at the Rainy Mountain Government Boarding School October 4, 1904." His steel-trap mind holds the whole history: "Rainy Mountain School opened September 5, 1893, and closed June 30, 1920. I was there nine months of the year. In my time, the grades only extended up to sixth grade. If you got your sixth-grade education, you were considered well educated.

"I still remember the first time Dad took us by wagon to the school. I was almost six years old and my brother was almost eight." As he speaks, you can imagine a day like this one, with the hot Oklahoma air so thick that your clothes feel glued to your skin. The dust from the horse-drawn wagon must have been unbearable, particularly since the destination was not eagerly anticipated. Parker continues: "I still remember the strange feel of the boardwalk to the boys' dormitory. I wondered, 'What kind of a world am I entering?'

"When I was a child, all I heard was Kiowa until I started school," Parker explains. "We were prohibited from speaking Kiowa at school; they were geared to stopping that 'wrong' language. So, whenever they caught us talking Kiowa—in the excitement of play we'd forget—then we'd get punished in various ways. In cases of severe infractions of the rules, you got a good strapping.

"The superintendent had a three-ply harness thong. I think he's the cause of death of one boy that I remember. He started whipping him with that three-ply harness thong, and he lost his temper and just kept on hitting him everywhere," Parker states. "In those days, when the school officials wanted to get information to parents, they sent a rider on a horse to convey the message. So, they sent the rider to notify the parents that the boy was sick and they should take him home. Within a couple of weeks after they took him home, he died—probably injured internally in some way. But, in those days, nobody thought about investigating deaths—it was just another dead Indian. That's as far as it got."

When Parker describes his life at Rainy Mountain from 1904 to 1914, it sounds like he was in prison. He tells of children dressed in blue uniforms doing early morning drills in weather so cold their fingers turned blue. He recalls always being hungry at school. "Our never having enough to eat was the most grievous. Years afterward, when I reminisce privately of Rainy Mountain days, I wonder if they even suspected that their laws at the time were authorizing civilized systematic genocide."

The bright spot in Parker's stay at Rainy Mountain was his sweetheart, and future wife, Nettie. Because of her, he started figuring out a way to write Kiowa—which was a solely oral language. "Nobody wrote Kiowa; there was no way to write in Kiowa." Parker remembers early attempts: "Nettie and I

tried to write to each other in Kiowa, doing it phonetically. Kiowa is very tonal, with a lot of nasalization."

Parker's work has been compared in importance to that of the famous creator of the Cherokee syllabary, Sequoyah. In 1991, Parker's efforts were recognized by the University of Colorado, which presented him an honorary doctorate. Parker even assisted many noted linguists, but his system has now been recognized as superior.

"Some of the Kiowa sounds don't match English letters," Parker says, and further explains that while there are Kiowa sounds that don't have any letter representations in English, there are also English sounds that aren't used in Kiowa. "I came up with the idea of using some of the extra English letters for our Kiowa sounds. For example, we don't have the 'J' sound, so I borrowed the symbol and use it for one of our sounds. I did the same thing with V, F, C, and Q. We don't have those English letter sounds in Kiowa either so I could also use those letters to represent some of our sounds.

"My system is the only one that you can write on the typewriter. I've spent my life perfecting my Kiowa writing system and compiling a Kiowa vocabulary." Parker was particularly interested in using the English alphabet because he was also an accomplished typist and valued the ability to transmit information via standard mechanical means.

After Rainy Mountain, Parker and Nettie went to Phoenix Indian School, in Arizona. Here Parker honed his office skills. "Since I was an office boy at Rainy Mountain, I said I wanted to be an office boy. But the main thing was that I wanted access to a typewriter so I could learn to be a typist. I had decided that it was going to be my fingers that earned my living, not my back," Parker explains.

Parker became an accomplished typist. "In fact, I was the second fastest typist at Phoenix Union High School. I could do ninety words per minute."

In March 1920, Parker became a full-time employee of the Indian Agency, later the Bureau of Indian Affairs (BIA). He retired after thirty-eight-and-one-half years there. "I never thought they paid me what I deserved. They never promoted me as fast as they promoted white clerks." Parker laughs, saying, "The joke's on them now because I have now been retired longer than I worked there. I'm getting my pension from the BIA, and they've paid me more than I ever earned in salary. So I'm getting even with them now."

Parker left Phoenix Indian School after three years, and returned to fin-

"My father was a white man who'd been captured by the Comanches as a child, then traded to the Kiowas."

ish school in Oklahoma. Nettie stayed behind to graduate from Phoenix. "I was home plowing my land when Nettie came home after graduating. I intended to sow wheat before I started back to school, then I wouldn't have to do a thing with it until the following June when school was out and it was ready to harvest. That's the way I had it planned—and it worked out real good. The following June, when I harvested my wheat, we made enough money to buy a brand new Ford Model T, $770 cash," he says, giving a broad grin.

"But I didn't go back to school. Cupid came along and shot me right through the heart. Nettie and I were married August 23, 1919. She died on March 25, 1978. We were married almost 59 years." The couple raised five children, three sons and two daughters; only their daughters are still living. Parker has twelve grandchildren, thirty-five great-grandchildren, and one great-great-granddaughter.

"Our oldest son, Bill, was born January 7, 1921. In World War II, he was a fighter pilot. He was shot down by German anti-aircraft fire and taken prisoner. He spent about nine months in a German prison camp until the war was over. He was the only Kiowa who got to be a fighter pilot. He died in September 1995." Parker is silent for a moment. "I thought it would kill me when I lost my oldest son; then in September 1997, I lost the other two sons in the same month.

Parker's mother, Au-kuan-do-nah, 1878–1967.
Photo dated 1911

"I am a Baptist. I was baptized in the Washita River. My faith gives me strength." And Parker has given his church the gift of Kiowa culture. "The linguist and historian James Mooney, who wrote a Kiowa history in the last half of the nineteenth century, said in his book that the Kiowa language couldn't be made into songs. But I did it. In 1986, I translated our Baptist hymns into Kiowa.

"Every morning I sing my favorite hymn in Kiowa, 'I am gratified that the Lord has helped me to see another day.'" He closes his eyes and the syllables of his ancient language come forth—the voice of the man who has preserved these sounds for future generations.

the cigarette to save the remainder for a few minutes later, when she will light it up again.

"My dream was to dance. I love to dance. I always wanted to entertain. It didn't matter if it was the Apollo or wherever," she sighs, recalling what she describes as the "happiest time of my life," the eight years she danced in the chorus line at that legendary theater. "There aren't very many rules to live by that will make you happier than following your dream. Don't let nothing stand in the way of your dream. And to get your goal, you have to go straight for it."

Scottie, as she is known to all, acknowledges that she was fortunate to have had the opportunity to realize her goal. "I had a good father, who encouraged culture. We were considered Negro middle-class. I was able to go to dance school and take music lessons and things like that."

Scottie's father, Frank Albert Young, was a sportswriter and sports editor for the *Chicago Defender,* which has been called the most influential African-American newspaper of the twentieth century. Founded in 1905, the paper crusaded for civil rights and urged blacks to migrate from the segregated South to the freer North. The paper had a national circulation, with more than two-thirds of its readers outside of Chicago. It was distributed across the Mason-Dixon line by black Pullman porters and entertainers who smuggled it into the South because white distributors refused to circulate it. The *Chicago Defender* was the first black newspaper to have a circulation over 100,000.

Frank A. Young encouraged black athletes and fought for the equality we now accept as "business-as-usual" in sports. On August 19, 1922, commenting on Negro League Baseball, he wrote a column urging, "Give us some brown skin umpires. It isn't necessary for us to sit by the thousands watching eighteen men perform in the national pastime, using every bit of strategy and brain work, to have it all spoiled . . . "

Because of Frank Young's reputation, many black athletes sought his counsel. Scottie remembers that from her early childhood through her adult years, many celebrity figures were guests in the Young home. When Jackie Robinson became the first black baseball player in the National League, joining the Brooklyn Dodgers in 1947, Scottie says, "He used to come to our house and cry like a baby because when he was in the outfield, people would throw garbage at him and call him 'nigger.' He was going to quit, but my father said, 'Just hang on as long as you can, because you're breaking the color line for all of us.'"

Frank Young was a single parent, Scottie's mother having deserted her newborn daughter and two-year-old son. Scottie says that her paternal grand-

mother and aunt filled the void and she never longed for a mother figure. She adored her father, and because of his position, loved everything to do with sports; and she tagged along with her brother in all his "boy" activities.

"I was always a tomboy, wanting to do everything my brother and his friends did. My father was very strict and conservative and thought I should be a little lady. But I was always climbing trees or something like that.

As strict as her father seemed, he felt he was no match for the onset of puberty and sent both children to boarding school for their high school years. Louise was sent to a Catholic school for African-American girls in Leavenworth, Kansas, while Frank Jr. went to military school. Scottie also completed two years of college at Wilberforce University in Zenith, Ohio, where she studied political science.

When she returned to Chicago, despite her education, good-paying jobs were hard for a young black woman to find. So, when the mother of a friend told Scottie about a job as an elevator operator in a beautiful hotel, Scottie grabbed it. "It was a hotel, but it wasn't a decent one. I didn't figure out what was going on until after I was there for a while." Now she gives a deep throaty laugh, explaining that the establishment was a brothel run by the famed gangster Al Capone. "I put two and two together. There were all these beautiful girls, and men were coming in all day. In many cases, they were carrying machine guns—in violin cases. Those men didn't come to see the girls; they were coming to meet with Al. He had his offices there. But they all were gentlemanly to me and I made good money."

Scottie, circa 1925

Scottie's love of dancing soon got her noticed. "I went to a dance and ran into a dance instructor from New York. He said that they were looking for chorus girls at the Apollo Theatre, and he asked me if I would like to try out."

Now it was time for Scottie to quit her elevator operator job of four years. "When I told them I was leaving, Al called me in his office and said, 'Louise, I don't blame you if you want to better your conditions; but don't ever say anything about what you heard or saw, or anything that went on

here, because there is nowhere in the United States you can go that I can't find you.' And, you better believe that I didn't say a thing for a long time after he was dead."

So, Scottie packed her bags and took the train to New York. "I was kind of nervous; I didn't know whether I was going to make it or not. I had to do three auditions. And I was the shortest one, so they put me in front and I had to lead the line of dancers out on stage."

"There aren't many rules to live by that will make you happier than following your dream."

The work was hard: four shows per night, six nights per week, plus daily rehearsals. But to Scottie it was glamorous. "There were always guys wanting to go out with the dancers. We used to call them 'Stage Door Johnnies.' They would give us roses, and we would say, 'Okay, we'll meet you,' and then we'd sneak out the side door and leave them standing there." You can imagine Scottie, dressed in an elegant evening suit and very high heels, out on the town. In the 1920s, the Harlem night scene drew all the 'in-crowd'—both black and white. "I had my pick of who I wanted to go out with. Usually they were musicians—some trumpet players, some sax players. I went to see Lena Horne at the Cotton Club many times. Then, on Monday nights all the big cabarets were closed and those musicians used to come in and jam with the musicians at the Apollo. That's how I met Count Basie and Cab Calloway. They were real gentlemen. But Billie Holiday was the most obnoxious person you ever met. She was high on that dope all the time."

Touring with the theater company to Washington, D.C., Scottie says she experienced real prejudice for the first time. "I sat down at the counter at a drugstore, and I notice everybody come in and this guy would wait on them, but not on me. So, I called him and I said, 'Young man, I noticed when everybody comes in here you wait on them, but I've been sitting here for quite a while.' And he just flat out told me, 'We don't serve niggers in here.' Well, I was floored. In show business I had been used to respect."

After eight years in New York, Scottie missed her father. Despite her urging and assurances that the dance performances and costumes were respectable, Frank Young would not come to Harlem to see his daughter "showing off her behind." So Scottie went home for a visit—and found something better than the Apollo.

At a dance in Chicago, she met her husband, James Scott, and never returned to New York. After they married, Scottie went back to school and became a court reporter. She laughingly says she chose this profession because, "I liked criminals! Anyhow, I always like mystery stories." James

worked as the maître d' at the Palmer House, one of Chicago's most exclusive hotels. The couple had one son, Elwin, and soon established a comfortable home life. "We were the first Negro family to move to Hyde Park Boulevard. It was kind of tough for a while," Scottie remembers, then adds with a chuckle, "but after they found out we weren't going to have barbeques on the front lawn, everything was okay."

With the birth of their son, Scottie became a full-time mom. "Elwin was a hellion when he was small. When he got to be a teenager, he was running with a gang of the wrong kind, and I told him, 'You have three choices. Either you stay here under my roof, and do what I want you to do, which is go to school and get your education; or else get out and get yourself a job; or go to the service.' So, I think he thought I was going to feel sorry for him, 'cuz he said, 'I'll go to the service.' So I signed him in at seventeen and it was a good thing, too, because two weeks after he was gone, the group that he was running with went to jail. Anyway, he liked it so well he made a career out of it. He was almost ready to get out when he was killed in battle."

Scottie also lost her beloved husband tragically. A drunk driver hit his car head-on, killing James instantly. After that, Scottie worked in the restaurant business and migrated West with her employer, working in his steakhouses in Kansas City and Phoenix. Later she worked in the cafeteria at the University of Arizona, but had to leave there, "because their insurance wouldn't cover me after age eighty." She then worked as a house cleaner for a wealthy couple, finally retiring at eighty-five. "Then I got into volunteer work," Scottie says proudly, showing off her wall of plaques and certificates for service to community organization and the county hospital, where she gave more than 1,000 hours of service.

At the time she retired, she also moved into a rent-subsidized residence for seniors and people with disabilities in an elegant old hotel, complete with a promenade of archways framing a swimming pool and courtyard.

While some centenarians complain of loneliness, Scottie has met all of her more than three hundred neighbors in the building. "You just have to keep making new friends and reaching out to help people," she says, stopping to greet a blind man sitting by the door. She became a 'second mother' to two young women, who have kept close friendships for decades. Although she lives by herself in a studio apartment, she is not lonely. As several women wave to her from the pool, urging her to join them, she states, "Life has been good to me. I have no regrets. Some tragic things have happened, but I can't do anything about them, so I don't dwell on the past. I try to live each day to the max."

FLOYD SCHMOE

BORN SEPTEMBER 21, 1895

Peace Activist—A sixth generation Quaker, Floyd has always adhered to the peaceful teachings of his faith. Born in Lawrence, Kansas, he served as an ambulance attendant in World War I. During World War II, he helped evacuate European Jews, and assisted interned Japanese-Americans. He has been nominated for the Nobel Peace Prize three times.

TALKING WITH FLOYD Schmoe about his life is a humbling experience. It is truly inspiring to realize how much one dedicated person can accomplish. A devoted human rights and peace activist, Floyd has been nominated three times for the Nobel Peace Prize. He helped arrange for the evacuation of Jews fleeing Hitler, built houses for Japanese atomic bomb victims, and built orphanages and dug irrigation ditches in Asia, Africa, and the Middle East. And this is just a partial list of his impressive accomplishments.

A sixth-generation Quaker, Floyd put his beliefs into practice early in his adult life when he refused to fight in World War I, but risked his life as an ambulance driver, retrieving the wounded and dead from the battlefields of France. It is easy to imagine this tall, lanky man, with a thick head of white hair and bright blue eyes, as a young idealist. His spirit is so strong that you quickly forget his wrinkled face and age-spotted hands, and see only his vigorous personality.

As a dedicated young pacifist in 1918, Floyd left his college studies to give aid to the soldiers: "I went to France as a conscientious objector. The

first major battle of World War I in which American troops were engaged was the battle of *Chateau Thierry* in early June. Because of this battle, the Germans were stopped about fifty miles east of Paris—in World War II they reached Paris. I was put on a sanitary train, made up of old sleeping cars, to pick up wounded soldiers and bring them into Paris hospitals. It was horrific—so many mutilated and dead boys.

"One satisfaction was that we helped everyone. German soldiers, once they were wounded, were no longer enemies—just seventeen- or eighteen-year-old boys. We gave the 'enemy' the same consideration we gave allied soldiers," Floyd observes, alluding to his Quaker-based belief that all life is valuable.

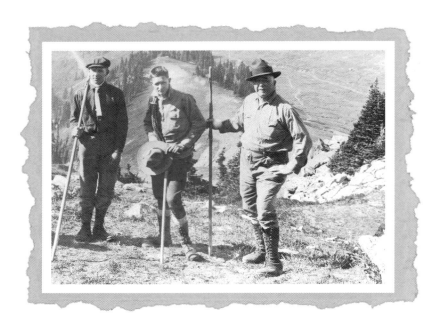

Floyd (center) Mt. Ranier, 1921

From the time he was a youngster, barely able to sit still through the weekly Quaker prayer meeting, Floyd was schooled in non-violence and hard work. He is the second of five children from a poor but resourceful family. His grandmother invented a process for quick-cooking rolled oats, which she sold in round containers as Purity Oats—which later became Quaker Oats.

As a boy, he loved the outdoors and the natural world fascinated him. "I was a born collector—fossils, rocks, bird eggs, leaves. With my interest in nature, I thought the Forest Service would be a good job," Floyd explains, "but the University of Kansas doesn't teach forestry. Well, my father and mother had been to Seattle in 1909 for the Alaska Yukon Pacific Exposition and told stories of clean water and tall trees. So I came to Seattle in 1917 with one hundred dollars in my pocket, which I borrowed from my Sunday school teacher and never paid back. I traveled by train on the *Empire Builder*—spent about seventy-five dollars on the ticket."

After his wartime service, Floyd returned to the University of Washington to continue studying forestry. In 1919 he wed his sweetheart, Ruth, a music student also of the Quaker faith. They had been married just short of fifty years when Ruth died suddenly of a heart attack in 1969.

The newlyweds' life and Floyd's college studies were soon to be up-

rooted by his strong sense of justice: "I was enrolled in physics, a required subject. At the first class, an Asian girl came in a few minutes late—maybe she'd had trouble finding the room. Well, that professor unmercifully bawled her out." Never being one to tolerate any hint of prejudice, Floyd took action: "So, I walked out and never went back. And without that course, I couldn't graduate."

Floyd's belief that each person can make a difference was soon reinforced by the actions of a total stranger. While working as a river guide during the summer, he met a wealthy man vacationing with his family. He was to become Floyd's benefactor. "This gentleman was the president of Nash Motor Company, and when he learned of my situation and that I wanted to transfer to forestry school at Syracuse, New York, he said, 'I've been blessed with more money than I need and enjoy helping people, particularly deserving students. I want to send you to Syracuse.' My wife, Ruth, would only accept the money as a loan. Well, after graduation, when I got a job with the National Park Service, I wrote that I had a salary now of $150 a month, and wanted to begin paying back the loan. He sent back the IOU with a note saying to put the money in the bank for our little son, Kenneth."

When he began his new job, Floyd became the first naturalist on Mount Rainier, Washington. Ruth and their young son lived on the mountain with him. Floyd says that he felt completely in his element—surrounded by trees and open space.

But this was not an easy life for a family. Floyd's voice trembles with emotion as he recalls their second winter: "The Park Service did not have adequate housing for their personnel, and we lived in a tent with our son. There was four feet of snow and only green wood for fuel. We could barely keep warm. When our second child was born, we couldn't get the doctor. We were snowed in. Our baby died. The hardest thing we ever did was bury her there. The Indians called Mount Rainier 'The Dwelling Place of God.' To me, it is holy ground."

Floyd worked on Mount Rainier for the National Park Service from 1922 to 1939, but got fired because of an issue of principle. He explains: "I had a friend in Philadelphia who taught at a private school and he wanted to bring the boys out for a trip around the mountain. So, I found a horse wrangler and a doctor who wanted to take the trip just for fun. It wasn't a commercial deal at all. Neither the wrangler, the doctor, nor I got any money out of it. We just wanted to show the students the beauty of the area, and I was glad to do a favor for a good friend. But the park company said that I violated their concession—they had a monopoly on all services in the park. They

said, 'Sorry, but we must let you go.' And I was able to say, 'That's quite all right with me because I've just been asked to join the faculty of the University of Washington.' I taught forestry there for fifteen years."

After the U.S. dropped the atomic bomb on Japan, thus ending World War II, Floyd was moved to action, performing acts of deep compassion, for which he has received international recognition: he built houses for the survivors of the atomic bomb.

"After Pearl Harbor, I was horrified by the U.S. retaliation. The Japanese didn't kill women or children. It was a military operation and—this is a terrible statement—they killed only about two thousand men. The Hiroshima bomb killed tens of thousands—thirty thousand children alone. And the second and third generations are still dying of leukemia.

"I thought someone should go to Hiroshima to show the Japanese people that not all Americans approved of the bombing."

"I thought someone should go to Hiroshima to show the Japanese people that not all Americans approved of the bombing. I thought if I went with my own hands and my own money and build a house for a surviving family, people would understand. I sent three hundred letters to everyone on our Christmas card list, and within days I had four thousand dollars. I took three other people; we built four houses that first year, all Japanese style built without nails—mortise and tenon.

"Hiroshima was bombed flat. The bomb knocked everything down— concrete houses, stone buildings, bridges—for a ten-mile radius. The fire, which followed, spread out even further. The Hiroshima we saw was a smoking desert," he says, still shaken by the memory.

Despite the horror of the bomb's aftermath, Floyd's memories of this trip are positive. He and his group became lifelong friends with many of those they helped. Floyd returned to Japan with volunteers for five years in a row, building more than thirty homes, although some of his fondest memories are from that first visit.

"We were invited to live in a lean-to shack next to a church. One morning, while I was still in a Japanese bath kimono, which only came to the middle of my thigh, the wife of the minister came running up yelling, 'Schmoe-san, Schmoe-san, people from the provincial office have come to see you!' And here I am in this kimono, when three men in formal tails come along carrying a letter placed on a silver tray because it was too important for them to handle. The letter was from Emperor Hirohito, thanking us for coming and making this gesture toward peace. The emperor gave me the Honor

of the Scared Treasure," Floyd says, proudly displaying a beautiful, jewel-encrusted medal.

But medals and awards aren't Floyd's motivation. The only reason he wishes he would win the Nobel Peace Prize is so that he could give away the money. He is currently concerned about children sold into slave labor and prostitution. "Think of how many I could help with that money," he muses.

Today Floyd's activities are limited because he is recovering from a fall and subsequent hip-replacement surgery. He writes daily, working on his second novel and seventeenth book, and reflects on his past and future. Some of his fondest memories and deepest regrets involve his six children. "I'm afraid I haven't always lived up to my own suggestions about how to live life," Floyd admits. "I've had a wonderful life; but because of jobs I undertook, I unintentionally put my family in difficult situations, or wasn't there for them. I would advise people to appreciate their good family and show that appreciation." The losses of his wife, baby daughter, and son, Kenneth, who was killed in 1996 at the age of seventy-six when a tree fell on him, all weigh heavily on Floyd. But, he brightens visibly when he talks about those he cherishes who are still on this earth. He is grateful for his friends and family, which includes ten grandchildren and thirty-seven great-grandchildren.

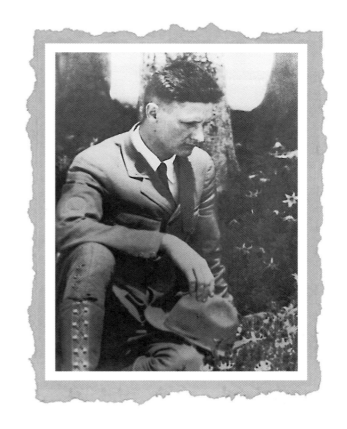

Park Naturalist, Floyd Schmoe, Mt. Ranier, Washington, 1925

He has a few words of wisdom to pass on to his descendants about living a long, fulfilling life. His first piece of advice, which he gives with a wink, is this: "Be very careful in the selection of your ancestors." Floyd followed that advice himself. Both his parents lived to the age of eighty-nine. Two of his siblings also enjoyed longevity: a brother lived to age ninety-eight and his younger sister, born in 1900, is still going strong.

Floyd also advises a healthy lifestyle of no drinking, drugs, or smoking. "And not too much hard work," he warns, then adds, "I'm basically lazy." Perhaps he's joking when he says that, but his next piece of advice is dead serious: "I've always believed that individuals are responsible for what happens in this world, that we can make a difference. So, take action. Don't be afraid. You must always have something important to do tomorrow."

the Lord shall be saved.' And I don't know why anyone would turn that down because it doesn't cost a thing; it's free."

Clara did not grow up in a religious household—just the opposite. Her father, Richard Steves, was an atheist; and although her mother, Maria, was a Christian, she kept her Bible hidden so as not to displease her husband. Even Clara's hometown of Comfort, Texas, was a-religious. It was founded by German immigrants who viewed organized religion with distaste because it had been forced upon them in their homeland, and they were seeking freedom from religion.

Clara, circa 1917

Growing up on a ranch in central Texas, Clara did not have a pampered childhood. Clara remembers her father as strict, being "very severe, and no discretion as to how hard a whipping he gave" if chores were not carried out. Clara's mother also expected adult behavior from her young daughter. Clara remembers experiencing a thunderstorm when she was about six years old. Frightened by the roar of the thunder and the flash of lightning running along the barbed-wire fence, Clara ran into the house to her mother. Maria derided Clara for being afraid. "'Go on with your chores; there's always danger everywhere,' Mother told me. We were expected not to make a fuss," Clara recalls.

Maria and Richard were caring parents, and their expectation that their children do their share of work on the ranch was probably no different from that of other ranching families. They were greatly concerned for the health of their children, who seemed to be continually sick—plagued by malaria, typhoid, diphtheria, and chicken pox. They sought the advice of a doctor, which was a costly endeavor in those days. The doctor suggested the family must leave the damp, swampy area of their ranch on the Llano River and move to California. After much thought, the family set out for San Diego on the doctor's recommendation.

Moving across the country in 1907 was not an easy undertaking. Richard converted an open farm wagon into a covered wagon. Clara remembers that her parents put a big mattress in the bottom of the wagon, packed in supplies of fruit and vegetables from their garden that her mother had canned, and

tied the cow so she came along behind the wagon. Clara says that the thought of the long journey did not upset her because she "knew Papa was at the helm, and Fanny was the best horse that money could buy."

Richard and Maria set out on June 9, facing the dusty summer heat of eastern Texas, with their four young children: Clara, seven-and-a-half; Alden, four; Richard, two-and-a-half; and baby Otto. Anyone who has ever taken a family road trip, and endured the constant question of "Are we there yet?" can only imagine what this trip must have been like.

By the time the family reached Las Cruces, New Mexico, from their home northwest of Austin, their supplies were almost exhausted. The cow had long been abandoned and fresh milk and food were required. On a modern highway map, this distance is almost seven hundred miles, but Interstate 10, or even old Route 66, did not exist then. On the outskirts of Las Cruces, Clara's father found an abandoned one-room adobe shack to house his traveling band while he searched for work and the family foraged for food. Two weeks later, after hauling lumber for pay, he returned with enough money for the family to continue on to California by train. The Steves family arrived in San Diego on October 31, 1907—four months after they left Texas.

The turning point in Clara's peaceful young life came on April 7, 1911, when her youngest brother, Otto, died suddenly at the breakfast table. The doctors said he had an enlarged heart. The shock and grief the family felt was devastating.

A neighbor and her pastor's wife called on the Steves family, offering condolences and a helping hand. The two women laundered the family's clothes and brought food and a five-dollar gold piece with a note of invitation to attend the church. Although Richard Steves had not been in a church since his wedding, he took his family out of gratitude for the compassion these ladies had shown.

"That was the renewal—the rebirth—of my life," Clara states. The pastor's sermon was about a young boy whose sister died, and how the boy found solace in accepting Jesus as his savior. Clara embraced the words of the evangelist and went to the altar and made a confession of faith in Jesus Christ. "What had been the saddest time in my life suddenly was filled with hope," Clara says, explaining how her acceptance of Christ gave her strength, purpose, and direction.

Clara began attending church and Sunday school regularly. "Our Sunday school teacher, who was a former missionary to Guatemala, also taught us practical homemaking skills, like sewing, which we would need when we

grew up. She also wanted us to be good Christian women and taught us the importance of charity and neighborliness," Clara recalls.

After high school graduation, Clara enrolled in junior college, set on a career in medicine; but some close friends convinced her to pursue teaching instead. So, she transferred to what is now the University of California at Los Angeles (UCLA) to get her teaching credential. Near the end of her second and last year at UCLA, Clara received an offer of a job teaching sixth grade—and she was to start the next morning. "A teacher had just left the school-room without notice, so I was brought right out of class from UCLA to teach in Riverside. I had forty-six sixth graders. It was too many, but the school board said they couldn't afford another teacher," Clara says. "I had only a few weeks to go until graduation, but how could I refuse to go where I was needed most?" Arrangements were made to provide Clara with her diploma and teaching certificate, and Clara packed that evening to report to her first teaching job the next day: March 9, 1920.

In 1998, Clara did go back to UCLA to receive that diploma with more pomp and ceremony than she missed in 1920. She received a standing ovation as her diploma was presented her by U.S. Secretary of Education, Richard Riley.

Since she was new in town, some of her pupils invited Clara to attend their church. And on that first visit to their church, Clara met her future husband, Rayford Shaver. "God made him just for me. He was the best-looking man in the world, and he was, I think, the 'goodest,'" Clara says. The couple met on March 21, 1920, and married on Clara's twenty-first birthday, December 29, 1920. Her face glows when she talks of him, and his picture is displayed prominently in her modest room at a retirement-living complex.

Rayford bought a half interest in the produce stand in a grocery store, and Clara often helped him in the business. "When I got married, I could no longer teach full-time. I was reduced to substituting, which I did whenever I could," Clara says to explain her shift in jobs. Their first son, Alvin, was born October 27, 1921, and a second son, Bobby, was born November 1, 1926.

The business did well, and Rayford bought a new truck and began a wholesale grocery business. Many nights, he would drive more than sixty miles to the produce market in Los Angeles, buy his wares, then return to Riverside to fill the orders from his customer stores. October 3, 1928, Rayford was on his way into Los Angeles when a truck driven by a drunk driver collided with his produce truck, killing him instantly.

Clara could not justify her faith in God with her anger at Him for taking her husband. But, ten days after Rayford's death, Clara had an experience

she calls "a spiritual healing." She reluctantly went to church on Sunday, afraid that she couldn't keep her composure in public. She describes a revelation she had as she sat and prayed in the Sunday school room: "I envisioned a pile driver trying to break through something hard. It was as if my heart were surrounded by a mass of worry about self, and the worldly clutter of life. I sensed the power of the Holy Spirit breaking through my anger and despair and piercing to the center of my heart." With renewed strength, Clara returned to raising her sons and spreading the gospel.

Since 1928, Clara has read scripture and prayed with the women inmates at the Riverside, California, county jail. Now, she goes to the jail twice a month instead of weekly. "I never was scared," Clara states. "It is more frustrating than frightening, especially when the woman who used to be in charge told me, 'I don't see why you come up here. You're wasting your time. Once a criminal, always a criminal.' I don't think I answered her at all because I was too polite to start an argument. But, I believe there is always hope for salvation. And as long as there are people in need, then I still have my work waiting for me. I am inspired by Psalm 37, verse 25: 'I have been young, and now I'm old; Yet have not seen the righteous forsaken . . .' There is no reason to stop trying to lead people to the righteous path.

"You have to look at your life sort of as a puzzle, and put each of the pieces in place one by one, and take the steps as they come."

"I think it is important to find your mission in life. Life can be like a puzzle—if you don't have a picture to guide you, then you don't have any idea of the puzzle. You only see a box of cutouts," Clara explains. "Every piece has its own shape—no two are alike—and if you want to put the puzzle together, you'll have to put each one in its niche. You have to look at your life sort of as a puzzle, and put each of the pieces in place one by one, and take the steps as they come. And if you don't put the right piece in the right hole, it won't be complete. So you have to be patient and have faith."

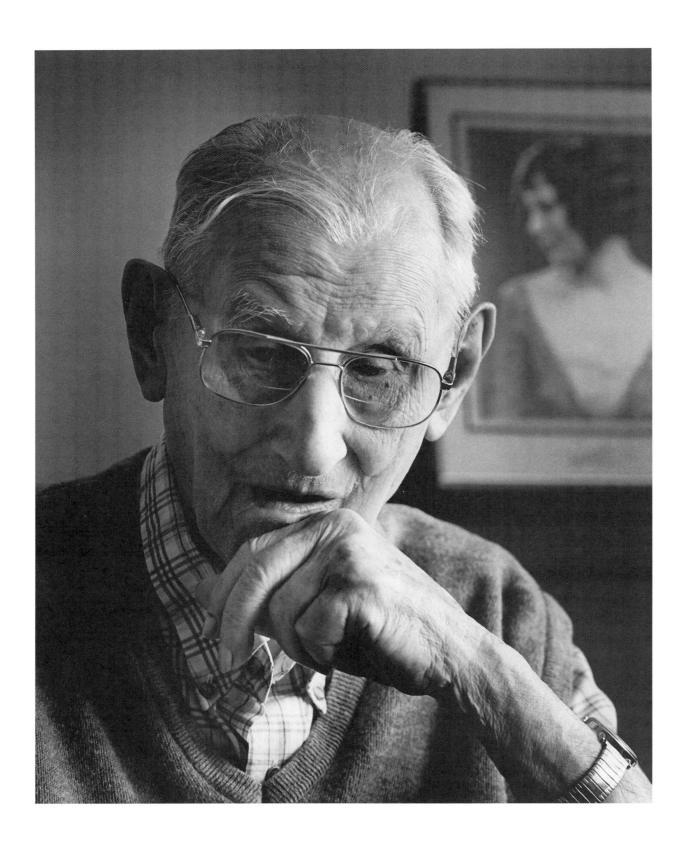

URBAN SCHICK

BORN OCTOBER 9, 1896

Baseball Player, Jazz Pianist, and Lawyer—Born in Evansville, Illinois,
Urban was a pitcher for the St. Louis Cardinals during the 1916–1917 season,
and a WWI veteran. He is also a graduate of the Kansas City School of Law
and enjoys telling a story about one famous fraternity pledge—Harry S. Truman.

"I KNEW HARRY TRUMAN very well. I was in the same fraternity with him, Phi Alpha Delta, when I was going to law school. I was a senior when he was a freshman. Since he was a pledge, we made him wash the dog, our mascot." Urban Schick chuckles heartily as he recalls these events from 1923. "We also made him mow the lawn while we all sat on the porch yelling for him to go faster. He was a nice guy and very popular over at the fraternity, just an ordinary fellow." He adds, "I voted for Truman every time he ever ran for anything. I've been a Democrat all my life."

Urban Schick clearly enjoys reminiscing about his famous friend. He has scores of stories to tell about President Truman and other Midwest-born luminaries including Jean Harlow, whom he knew as Harlean Carpentier and dated briefly; U.S. Supreme Court Justice Charles Evans, who was also a law school classmate; and poet Wallace Stephens, who was a co-worker.

But, Urban Schick modestly discounts his own accomplishments, which made him a local celebrity in his younger days. Before his law school adventures, Urb pitched baseball for the Saint Louis Cardinals from 1916 to 1917,

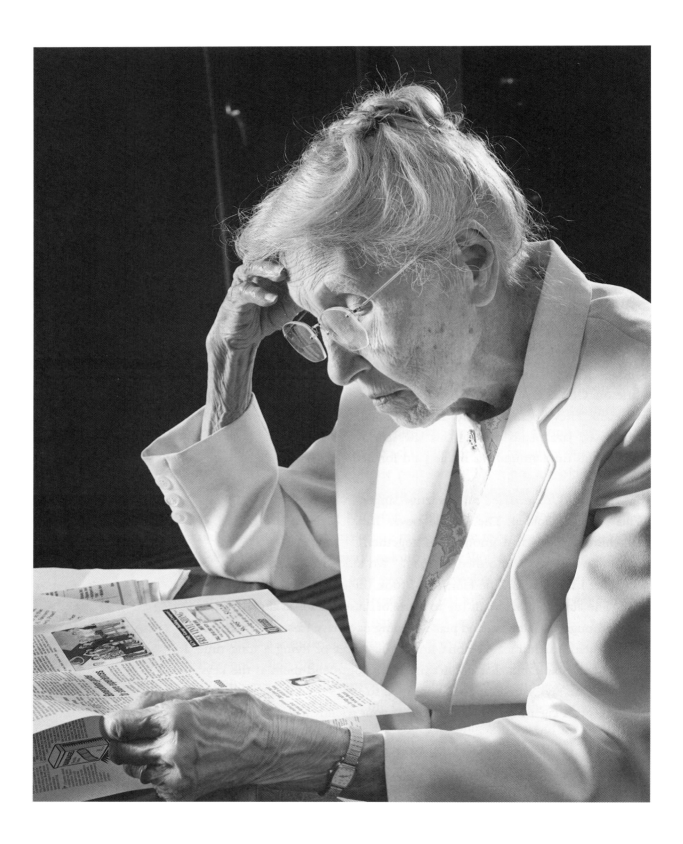

Audrey Stubbart

BORN JUNE 9, 1895

Homesteader and Journalist—Born in Newman Grove, Nebraska, Audrey Stubbart has been on the staff of the Independence (Missouri) Examiner *since 1965, writing, proofreading, and editing. She came to journalism after homesteading in Wyoming and raising five children.*

AUDREY SCOFFS AT the idea that she is the second most famous citizen of Independence, Missouri—second only to the town's favorite son, president Harry S. Truman. However, on her one-hundredth birthday, Audrey became an instant celebrity—a predicament she has dealt with gracefully ever since the phones started ringing off the hook with requests for interviews. Audrey has patiently and politely answered *the question* (for what seems to her the millionth time) that inquiring interviewers from all over the world ask: "What is the secret to longevity?"

"I don't have an answer for that," she says almost sheepishly because she knows, as a newspaperwoman, that nothing frustrates a journalist so much as the lack of an answer.

Audrey is not generally at a loss for an answer to any question. Her job is to catch other people's mistakes and find answers to all manner of questions. She is a proofreader at the Independence, Missouri, daily newspaper, the *Examiner.* Her love of the English language drives her to find just the right word and correct grammar. Audrey also writes a column called *Ask Audrey,* in

which she responds to questions sent by mail—both postal and electronic. She has also written a regular column featuring her memories of pioneering life and commentary on contemporary life. Audrey began this job in 1965 after mandatory retirement at age seventy from a religious publishing company where she had worked since 1944. And she still does this job five days a week, eight hours a day.

Every weekday morning at 7:30 Audrey takes off her hat, places it carefully in a corner of her desk, and takes up her red pencil. Audrey believes that keeping active and making a contribution are what keep her going. "If I couldn't come to work, I'm sure I would have died years ago. I've got too much energy, too much ambition, and too much get-up-and-go to retire," she says, and she has no plans to do so. "I have to have something valuable to do," she states emphatically.

And her colleagues at the paper consider her invaluable. Although they may go out of their way to stop by her desk and give her a daily hug, she is treated like the elder stateswoman of the newsroom. She has definitely earned this position of respect; everyone on the staff acknowledges her capabilities. Aside from the special affection her coworkers show her, she is just like any other member of the staff. Her desk is similar to those of the other reporters and editors in the bustling newsroom. A computer holds the place of prominence, surrounded by reference books, dictionaries, style manuals, and stacks of papers. The newsroom reminds one of the setting for the once-popular *Lou Grant,* a television show starring Mary Tyler Moore, except that computers rather than typewriters occupy the top of each desk. And there is more chaos in real life. Directly over Audrey's desk, a police scanner broadcasts traffic accidents, incidents of domestic violence, fist fights, fires—the stuff of the daily news. The noise is deafening. Audrey, however, has no problem hearing well enough to field phone calls.

With her sharp mind and piercing blue eyes, she doesn't miss a thing on the pages either. Even while having her own portrait taken at her desk, she critically reviews the small 1.75-inch-by-2.25-inch Polaroid test image, and announces that her wispy fine white hair needs re-combing before the final photos can be made.

It is obvious that when it comes to this great-great-grandmother, you must let go of common preconceptions. Nothing about Audrey is ordinary. Even for someone born at the turn of the last century, she's done more than most. She homesteaded in Wyoming, raised five children, taught in a one-room school, was the midwife for dozens of babies and became undertaker

to many of them and their relatives, played the organ and sang at weddings and funerals, traveled the world, and has held a job in publishing for more than fifty-six years.

She even remembers when the century turned. "Mother spent a lot of time teaching me about the calendar. And when the change to 1900 came, here were those two zeroes instead of what I'd learned for so long, 1899. It was a forecast of my abilities—or lack of them—with mathematics," she says with a chuckle.

Audrey learned her work ethic growing up on the Plains from the example set by her parents, Arlo and Etta Belle Morford. Audrey, the oldest except for a child who died in infancy before her own birth, had three younger brothers. Audrey's mother later also raised her own baby sister, who was a year older than Audrey, after her own mother died. Audrey recalls that during her parents' early years together times were difficult. "I was born in the last year of a four-year drought that began in 1891. My parents had sunk everything into establishing their farm and lost it all."

After their venture failed, Arlo worked as ranch foreman for the Will Bell cattle ranches of Tabor, Iowa, and Gordon, Nebraska—a position that forced the family to move almost annually. At this job, Arlo supported his family on thirty dollars a month "and found" in wages. As Audrey explains, "'And found' meant they could grow all the food on the place that they wanted to." Audrey recalls that her mother always had a big garden, a practice Audrey herself continues to this day. During the summertime she can often be found harvesting her strawberry patch—while four-year-old great-grand-daughter Ivy tags along, eating the berries almost as fast as Audrey picks them.

"I was born just seven years after the battle of Wounded Knee, and feelings between the Indians and the white settlers ran very high."

In her Christmas Eve 1997 column, Audrey describes her childhood home, "Close your eyes and picture with me the treeless plains and sand hills of western Nebraska as we saw them in 1902, dotted here and there with sod houses and windmills. Some of the houses were covered in summer with blooming portulaca—rose moss—and in the winter they were inviting with smoke curling from stoves burning cow and buffalo chips and willow branches.

"Our house was a little more palatial (frame) set in a sad little windbreak of cottonwoods and willows with a few young apple trees next to the house. . . . Every ranch or homestead had a windmill, for water was a scarce commodity. The homesteaders washed their faces and hands at the out-

door washstand and threw the water on their sod house to water the flowers."

Audrey closes her eyes and recalls her family home, "Off the big ranch kitchen to the right was a large bedroom where we children slept. It was from the windows of this room that Mother regularly watched through the night, with her rifle across her knees, to guard against the possible attack by the Indians camped on the hillside. I was born just seven years after the battle of Wounded Knee, and feelings between the Indians and the white settlers ran very high."

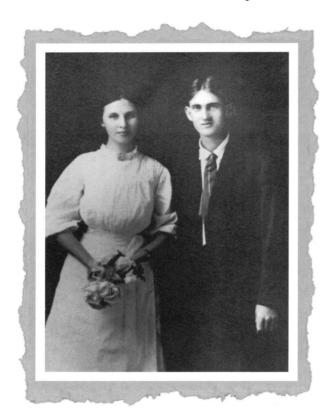

Audrey and John Stubbart, wedding day, February 1, 1911

Audrey remembers her family life as happy: "With such love as we saw shared by our parents, we never missed any of the things children have come to expect nowadays. We didn't need material things. I wouldn't trade the love light in my parents' eyes for all the world's riches. I wish every child could have as good a birthright as I had."

Audrey particularly remembers that their home was filled with music. "After dinner, Daddy would sit down at the organ he had bought Mother as a wedding gift, and he and Mother would play and sing, 'When the roll is called up yonder, I'll be there. . . .'" Audrey sings. Her soprano voice quivers as she remembers her parents. "He had such a good bass voice."

"I recall one day Father arrived at the door while Mother was still scrubbing the floor. When he saw Mother's efforts, he put his arm around her and began to sing: 'Could I but live with my own sweetheart in a hut with a sanded floor, I'd be richer by far than many a man with kingdom and gold in store.' Mother sang the refrain in her soprano, 'For home is where the heart is, in a dwelling great or small. But a cottage lit by love light is the dearest home of all.'" Audrey sings, for the moment lost in time. "Looking back now," she adds with a knowing nod, "I presume the gleam of 'love light' in father's eye was the promise of our little brother."

Now, her voice trembles with emotion as she recalls her father's death. "Daddy died so young. He was thirty-six. I was seven, almost eight. It was

almost one hundred years ago, in 1903. He caught pneumonia working out in a blizzard and he died four days later. He was so sick that Mother put him to bed. She told me to watch him, not to let him leave the house, while she went out to do all the chores," she says, as tears roll down her cheek. "Our baby brother, Kenneth, was born the July after Papa died."

After Arlo's death, Etta Belle moved her family to Iowa, near relatives. There, the family was converted to the Reorganized Church of Jesus Christ Latter Day Saints (RLDS) and became very involved in the church. Audrey remains active in this faith today. She feels that the strength she finds through her faith is one of the factors that has contributed to her longevity. She also credits her health to another facet of the teachings of her church. "One of the big factors in my life is my religion. I learned from my religion to be temperate in all things."

The family's move to Iowa also brought Audrey the second man in her life, her husband John, who was five years her senior. Audrey describes him as "the handsomest fellow I'd ever seen." John's family also was active in the RLDS church; his father was a minister. John and Audrey wed February 1, 1911, a few months shy of Audrey's sixteenth birthday. Their first child, a daughter they named Enid, was born October 5, 1912. The couple had four more children: three sons, Veryl in 1914, Donald in 1921, and Kenneth in 1930, and another daughter, Carol, in 1928. All five are still living. Audrey has nineteen grandchildren and says, "I lost count of the great-grandchildren after twenty-five, and I think there are at least six great-great-grandchildren."

John's minister father, James, was also a geologist and often combined missionary work with his expeditions. James had established a church mission in Wyoming, and when the area was opened for homesteading in 1915, he encouraged John and Audrey to go to Wyoming to homestead.

The harsh starkness of pioneer life on the windswept, treeless Wyoming landscape was the anvil on which Audrey's personality was forged to its iron strength. "We had some rough times, but they made us better. Hard times make you stronger," Audrey reflects.

Audrey responded to the austere and demanding environment by becoming a civilizing force on the barren terrain. First, she and John built their home with the help of John's father and their neighbors. "We lived for a while in a tent, then we built our house of thirty-six-foot timbers. It was a

"If you do something because you have to, it doesn't mean much. But, if you do it because you like to and you enjoy it, it becomes special."

log house, not a cabin," Audrey says with pride. "We had two big rooms. I had to have room for my organ. We shipped it on the cattle train—the livestock was in one part and our furniture was in the other end. We moved into our house the day before Thanksgiving—the most thankful Thanksgiving I ever had. We just put our arms around each other and cried."

Audrey's work ethic was soon honed. The couple raised sheep and cattle. The harsh winters and economics of ranching often took their toll. In 1930, the effects of the Depression hit home. John deposited all the proceeds from the sale of their spring lambs and calves in the local bank, only to have the bank fold the next day and all the family's funds disappear. In the spring of 1933, a severe blizzard killed all the lambs. Still the family persevered. "We loved those wide-open spaces and that big sky," Audrey reflects.

Audrey's desire to be of service also was shaped by the necessities of rural life. She became a teacher and a midwife. She helped conduct church services and taught Sunday school. She embraced each of these callings, trudging

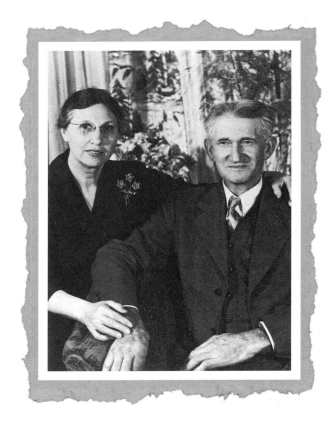

Audrey and John, circa, 1945

through snow to deliver babies, or a lesson.

Snow and weather were not the only obstacles she faced. Daughter Enid, also one of Audrey's students, remembers one trip to school when, "Suddenly a coiled rattlesnake started hissing and was close enough to strike. Mom made a flying leap, landing with her heel on its head, driving it into the ground!"

Despite such physical hindrances, when the families in the area approached Audrey to become a teacher for their children, she welcomed the opportunity as a chance for her to learn as well. "I had to quit school after the eighth grade and was brokenhearted." Then she adds, with emphasis, "But I went back; I went to school every time I got a chance."

She took courses to get her teaching certificate. She remembers once, however, when her enthusiasm for her studies was overshadowed by history itself. "I was taking a teacher's examination when the principal, Mr. Jones, swung open the door and said in his deep voice, 'The Armistice has been signed!' It was November 11, 1918. Studies were almost forgotten."

After twenty-eight years in Wyoming, John and Audrey concluded they were ready for a change. They decided to move closer to family in Missouri. "We really were pioneers," Audrey says of their homesteading years. "Our original plan had been to stay for seven years and then get back to civilization. We sold the 2,100 acres we had gradually acquired for $1.75 an acre. We bought a place with two houses on two acres for $6,500." Although John died of a heart attack in 1965, Audrey still lives in one of those houses, and her youngest daughter, Carol, lives in the other. In reflecting on her parent's fifty-four-year marriage, Enid describes it in very much the same terms Audrey describes that of her own parents, "They were pals, good and true. There was a lot of love in our home."

In reflecting on all her adventures and accomplishments, Audrey has some solid advice, "If you do something because you have to, it doesn't mean much. But, if you do it because you like to and you enjoy it, it becomes special. We should apply that to all our efforts."

days, I had to dance around by myself. I can remember how ugly people were to me. But I didn't let it bother me—it's just the way it was at the time. I was sure I was right and it spurred me on to do the right thing."

Hortense's positive self-image and confidence were instilled by her nurturing parents. Both teachers (although her mother sacrificed her career to raising her three daughters), they stressed education, culture, achievement, and community involvement. Hortense's father, Ezekiel Ridley, was a mathematics teacher and grammar school principal. Decades later, his school was part of the barrier-shattering case of Brown v. Board of Education, which was intended to end school segregation. Ezekiel Ridley made sure his daughters knew that they were valued.

"We had a children's hour every night, when we would tell each other all the things that had happened during the day. Even if we were bad at school, we had to tell—just like we would tell if we were good. It wasn't so that we would get punished; it was so that we would all know about what each of us was doing," Hortense explains. "My father called the family 'a corporation' and everybody's ideas were given a voice to be heard. We all voted on family decisions."

This supportive atmosphere was built on the foundation of the struggles of Hortense's paternal grandfather. Born a slave, he became a farmer in Tennessee after the Civil War. "One day he went into town to get a new ax for chopping firewood." Hortense retraces the family's journey: "White people were afraid that the former slaves might start an uprising, and it didn't look good for a colored man to be buying an ax. So, the Ku Klux came by his house to scare him. Well, my grandfather was a widower with five little children, and he grabbed those babies so fast and moved to Kansas because it was a free state, never had been a slave state."

Because of Ezekiel Ridley's involvement in the community and status as an educator, the family often hosted important visitors. "You see that old chair there," Hortense motions to the corner. "My neighbors were telling me I should get rid of it because it's so beat-up. But, I can't tell you how many people had sat in that chair—famous people who came to our house in Kansas. My father took people over to his school and then brought them home because he loved and adored us and wanted us to meet these wonderful people. Oh yes indeed, Booker T. Washington sat there. And so did George Washington Carver. Now, how can I get rid of that chair?"

It was also a necessity of the times that renowned visitors stayed with the family "because they couldn't stay in the hotel, you know," Hortense explains. Because of segregation, travel presented many difficulties, even for pioneer-

ing educators such as those recalled by Hortense. She reflects on some of her own travel experiences: "You would always have to arrange for people to take you in, so that you had a place to stay. And you couldn't eat in restaurants, so you always had to pack a lunch. Once, I went by bus to visit some relatives. When the bus stopped at a place along the road so everyone could get something to eat, I had to just sit there on the bus. I couldn't eat with the other patrons."

Hortense developed a defensive approach. "Even as a child, I would not go into a movie theater that was segregated. So, I didn't see a decent movie until I was an adult and went into New York. Even today, I will not go to the theater here because they used to segregate years ago. My friends would say, 'You miss this or you miss that.' And I'd say, 'I'd rather have my dignity. I will not be segregated. I cannot take it,' and I wouldn't do it.

"There were no Negroes allowed in some things in this town," Hortense recalls. "I can remember one time, my husband and I went uptown to shop for something, and I saw

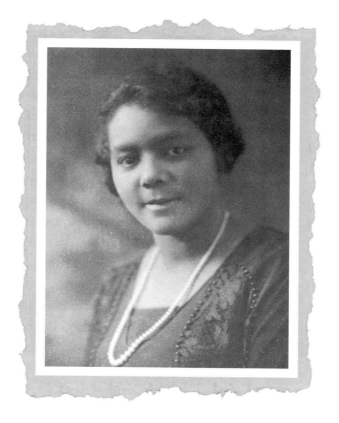

Hortense, circa 1922

a group marching around a place, to try to get it to be open to Negroes. So, instead of going to get what I had come to town for, I started marching too. But you know, it was always that kind of thing, we were always trying to push forward."

One of the ways to push forward, Hortense's family taught her, was through education. Like her two sisters, Hortense graduated from college and became a teacher. However, her teaching career was not a conventional one— it did not start in the schoolroom. "When I was finishing at Washburn University in Topeka, a woman from National YWCA came to recruit and she looked at me and she said, 'You look like you would be just the kind of a young woman to work with girls.'" Hortense gives a throaty laugh. "I majored in English and minored in history. Those were the things that I was interested in. So here I was in Montclair, New Jersey, teaching etiquette and leading nature hikes. In those days, girls took sewing, and the only thing I ever failed in school was sewing."

But, Hortense did excel at her job, organizing clubs and activities for the

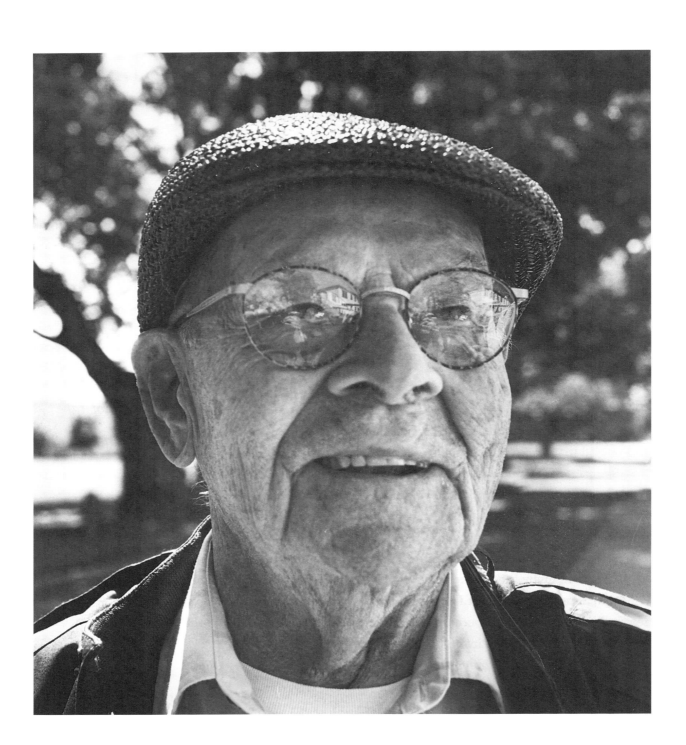

Francesco "Frank" Giovanni Orsi

BORN AUGUST 5, 1899

Italian Veteran of World War I—Born in Santa Andrea near Lucca, Italy,
Frank served in the Italian army during World War I. Seeking a better life
and disagreeing with the rising political popularity of Mussolini, Frank came to the
United States in 1922, later serving in World War II in the U.S. Army.

"IN 1917, I was on the Austrian Front—a machine gunner in the Italian Army. Italy and the U.S. were allies in the First World War," Frank Orsi states. He remembers the battlefields of World War I clearly, as if he were there yesterday rather than more than eight decades ago. In his soft, accented voice, he continues: "The gun I used took two men to carry it. I've seen one in a museum; it's called a Lewis Gun."

Frank doesn't like to dwell on his war experiences, preferring that those memories remain part of his history, not his present. Joining the army had not been his choice. "I was eighteen years old when I was drafted into the army. I was in the army for forty-six months. After the war was over, they kept me for another year." He shakes his head, hesitant to discuss anything else about the war—indicating that there is not much good that can be said about the battlefields of Europe. "I am a very lucky man; I was never wounded. I saw so many people die, it was awful."

The war changed Frank's outlook. When he returned to his peaceful farming life, he was seeing things as if with new eyes. "I came home to the house I was born in, which was built in 1600. My family had been living there for generations. But after six months, I thought, 'What am I doing here? I work and work, but I don't get anywhere. I can't get ahead.'"

Frank concluded that it was time for him to make changes in his life. "Three of my brothers had gone to Brazil before the war. I had a sister and brother-in-law who owned a restaurant and hotel in Roseville, in Northern California. So I said to myself, 'I'm going either to Brazil or to the United States.' I decided on the United States, and I don't think I made a mistake," he says, his broad smile vouching for his sincerity.

"Mussolini was becoming popular in Italy. When he started allying with Germany, I knew it was bad. Most people were against it, but he was an absolute leader—too much power. So I got out."

The depressed post-war economy was not the only reason Frank felt the time was right to leave his homeland. He explains that he was not in agreement with the political winds which were blowing across Europe. "Mussolini was becoming popular in Italy. When he started allying with Germany, I knew it was bad," Frank states. "Most people were against it, but he was an absolute leader—too much power. So I got out."

Frank left for America in December 1921 and spent New Year's on the ship crossing the Atlantic. "It took twelve days to get to New York. Then, I had to stay at Ellis Island for about ten days while I waited for my brother-in-law to send me money. I had no money left, but soon after I got to California I was able to pay him back. I took a train for three days to get to California."

Frank's brother-in-law put him to work in the hotel restaurant immediately. "He gave me a job washing dishes. He paid me about two dollars per day, which was pretty good in those days. And I paid him board and room of one dollar per day and stayed in their hotel."

Frank explains that the hotel did a very good business. "The Southern Pacific Railroad went through the town and about ninety percent of the business in the bar, restaurant, and hotel was from people working with the railroad or traveling on the railroad."

As grateful as he was to his family for helping him come to California and giving him a job, Frank did not forget that his original reason for leaving Italy was to better himself economically. "After six months, I asked my brother-in-law if he would make me a partner, so I could make a bit more

money. And he did. I stayed there six years and I saved about six thousand dollars.

There is a tone of pride in his accomplishments when Frank recounts his efforts to achieve his goals. He smiles broadly remembering his first prized purchase: a Harley Davidson motorcycle he bought in 1925 for two hundred dollars. "I would go into San Francisco to Italian restaurants. The traffic in those days was a lot less. Now, I wouldn't want to take a motorcycle on the freeway. I kept the motorcycle about five years, and then I bought a new Model A Ford for about eight hundred dollars."

Even today, Frank is proud of his independence and mobility. He still drives his own car, a late-model Toyota. Frank was about half an hour late for his interview appointment because he had taken his car in for routine service first thing in the morning, and the mechanic took longer than Frank expected.

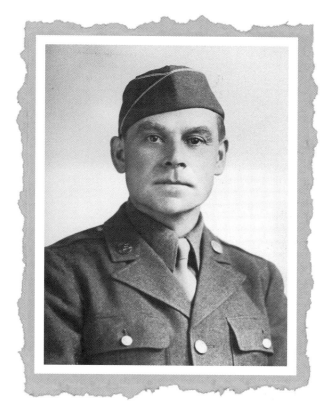

Frank, circa 1942

Frank is now retired from farming. He sold most of his acreage, keeping his house as rental property, and now lives in a retirement community run by the California Department of Veterans Affairs. However, at least once a week he drives into town for a home-style Italian dinner and a glass of red wine with his buddies.

Frank was also interested in improving himself educationally, not just economically. Today reading is one of his favorite pastimes. And even though his formal education ended at age twelve, Frank is well informed and comfortable discussing a wide range of topics. Keeping his mind active is probably one of the factors that has contributed to his longevity.

"I had to quit school in Italy to work on my father's farm, but I could read," Frank states proudly. "I made up my mind that if I lived in America I had better speak English and read English. So, I taught myself because I didn't have time to go to classes to learn it. I learned to understand English by reading newspapers. I can speak and read English, but I can't write as good because I don't know how to spell. It's hard for me because I learned spelling in Italy."

Once he had mastered the language, Frank was ready to become a full

American. "I studied books, and then took the test about the government, congress, the presidents. I became a citizen in 1935," he says proudly.

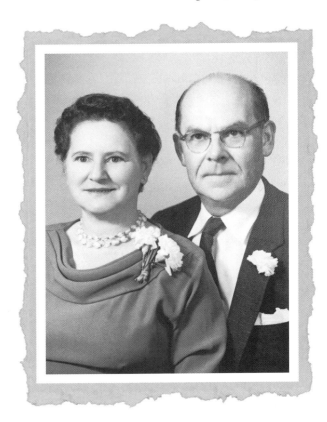

Frank and Teresa Orsi,
wedding day, August 5, 1954

Less than a decade later, Frank found himself called to serve his new country. "In World War II they drafted up to age forty-five," he explains. "I was forty-three and still single, so they got me. Luckily, I wasn't sent overseas. My company was sent overseas, but I was on leave when they went so I missed it. I fought once; that was enough."

Frank finally married at age fifty-five. His wife was a widow. "Teresa and her husband farmed asparagus on an island nearby my ranch," Frank explains. "She knew my family; I knew her family. After her husband passed away, I would visit her. Two years later, we decided to get married. Teresa was born in Italy, too. We used to cook together really good. She was a good woman. Look at that beautiful smile," Frank says, pointing to their wedding portrait. Frank thinks this is the secret to their good marriage: "We were a balance to each other. She was hard-headed. I'm not hard-headed. I'm very patient."

In 1962, the couple decided it was time to retire. "We sold our walnut ranch. The trees were old and dying and we didn't want to start replanting. We were starting to get old and would need to hire help and then all our profits would go into hiring workers."

They then went to Italy to see their families. "We stayed for four months and saw a lot of changes," Frank chuckles. "When I left in 1922, you were lucky if you had a bicycle. Forty years later, cars were everywhere—Fiats even caused traffic jams in my old village."

With a tone of resignation, Frank says, "My wife was a diabetic, but she wouldn't take care of herself, wouldn't take her medication. She died in 1985. She was two years younger than me."

In contrast to Teresa, Frank is resolute in taking care of himself, and is grateful for his longevity. "I am very, very glad to be able to say that I've lived in 1800, 1900, and 2000! Not many can say that!" he says with a hearty laugh. Although his longevity may be partly genetic—his parents lived to their

mid-eighties and he has a younger sister in Italy in her nineties—Frank also feels that he has played a part in his good health.

"My doctor asked me, 'What's your secret to long life?'" He laughs, "She's asking me, and she's the doctor!" But, he has a solid answer: "I told her, 'Don't worry about anything, that is number one. Next, take care of yourself and enjoy life. A little drinking is all right, but no smoking. I quit smoking thirty-seven years ago. I go out for an Italian dinner and I have a glass of wine. But it doesn't bother me not to have any wine. I can live without it. But, don't eat too much.'"

He adds that the most important thing is, "Keep moving; take a walk every day."

"I am very, very glad to be able to say that I've lived in 1800, 1900, and 2000! Not many can say that!"

ℋazel 𝒲olf

BORN MARCH 10, 1898

Environmental and Civil Rights Activist—Born in British Columbia, Canada,

Hazel came to the United States for better opportunities for herself and her young daughter.

During the Great Depression, she joined the Communist Party and fought for

workers' rights. After she retired at sixty-seven, she pursued her love of nature, helping to found

more than twenty Audubon Society chapters in the Pacific Northwest, Canada, and Russia.

WHEN HAZEL WOLF speaks, her tone is gentle, but persuasive; her voice soft and melodic. But that voice is unwavering and fearless, too. It resonates with both strength and conviction—qualities that have served as the foundation for her accomplishments all her hundred-plus years. Hazel Wolf is a firm believer in taking personal responsibility for making the world a better place. She has always boldly pried opened doors that many others thought were nailed shut. She attributes her courage to an experience that she had when she was five years old.

"When I was a small girl, the acceptable way to discipline children was to either spank them or scare them with the threat that the boogeyman was outside waiting to get them. My mother subscribed to the boogeyman school of discipline to keep me in my place. One particular time when I had done something wrong, my mother threatened me that the boogeyman was coming. Somehow, I had just had it with this boogeyman stuff. So, you know what I did? I went and opened the door. And he wasn't there. The

boogeyman *was not there*. That taught me something very important, something that I really needed to know. The boogeyman is *never* there. So now I open *all* the doors because I know there's nothing to be afraid of."

Hazel immigrated to the United States in 1923 from Canada, seeking better opportunities for herself and her young daughter, Nydia. Unlike many female immigrants of that era, however, Hazel—always the independent woman—had career plans.

Hazel, circa 1917

"I wanted to become a nurse. I wanted to help people; I was determined to help in some way. I tried to become a nurse in Canada, but they wouldn't accept me because I was married, so I took my daughter and left my husband in Canada," she explains. "I thought, 'I'll come to the U.S. and I won't tell them I'm married.'" (The couple eventually divorced. A later second marriage also ended in divorce, but gave Hazel the name Wolf.)

Admittedly, being a single mother was hard work and, in the early part of the twentieth century, it carried a social stigma. Hazel never dwelled on her hardships, though. She always focused on how she could make things better. Her positive attitude and activist nature have probably contributed to her long life, for they have always given her a goal. Her desire to fight for causes that improve people's lives is evident in the story of how she stumbled into being an activist for workers' rights.

"In the middle of the Great Depression, I, like millions of others, was unemployed. There was no unemployment insurance, no social security for retirement, no industrial insurance for injuries. All we had were food vouchers. A man was outside the voucher station circulating a petition urging the state legislature to set up unemployment insurance. I thought it was a fantastic idea. I asked who wrote the petition, and was told it was the Communist Party. I didn't even know there was a Communist Party in the United States. I decided that I wanted to know more.

"I joined the Communist Party in 1934. This was not, and still is not, illegal; it was just another political group. We demonstrated; wrote letters; struggled for food, for housing, against racism, and for the rights of women.

I have never lost respect for the work we did to try to make life better for workers."

As the country eased out of the Depression and people gained employment, Hazel became busy with a new job and found fewer and fewer reasons to be active in the Communist Party. Although she stopped paying Party dues in 1942, her benevolent efforts would come back to haunt her. During the McCarthy witch-hunt, she was arrested because of her previous involvement with the Communist Party. Indeed, when Red Fever hit the U.S., Hazel's case received international attention. The British press dubbed Hazel, who was then in her sixties, "The Red Grandma."

When Hazel tells the story, you can hear the indignation in her voice. "They tried to deport me. You can't tell I'm an immigrant because my skin is white and I speak with an American accent, but many of the victims of the McCarthy witch-hunt were immigrants. The foreign-born are the most vulnerable because they do not have the same Constitutional protection as the native-born. The foreign-born are not protected by the Bill of Rights because a deportation hearing is a civil action, not a criminal action."

"The most important thing is to do what you want to do, and that's different at different times in your life."

Hazel took her case to court, and it took fifteen years in the labyrinth of the justice system before it reached the Supreme Court. Fortunately, she was working as a legal secretary for a civil rights lawyer who, according to Hazel, was the only lawyer in town who would defend Communists during the McCarthy witch-hunt. "I always told my employer that I worked for him, but he would say, 'No, I work for you.' Since he was handling my case, we never did settle that argument!

"When my case was going up to the Supreme Court, a friend of mine knew Justice William O. Douglas and wrote him a letter about me, urging that I not be deported. She got a postcard back from him saying, 'Tell Mrs. W. not to worry.' That's the shortest Supreme Court decision I ever heard!"

When she won her long struggle to get the deportation order canceled and her case was closed, Hazel proudly became a U.S. citizen. A staunch Democrat, her only regret is that Nixon was the president when she swore her allegiance!

At age sixty-seven, Hazel decided to retire and pursue her love of the outdoors. She still enjoys the sports of her girlhood—canoeing, kayaking, swimming, and hiking. These interests led her to what would be one of her life's missions: saving the environment. She discovered this mission in a

roundabout way. Just before she quit working, Hazel agreed to go on an Audubon Society field trip to quiet a pestering friend. Although she had doubts about going out with "a bunch of bird watchers," she was soon absorbed in that pastime. She vividly recalls that outing: "So there everybody was, staring at this little bird. It was going up this tree, picking as it went up, obviously eating something. When it got to the top of that tree, it dropped down to the bottom of the next tree and started all over again. I thought, 'That bird works hard for its living and I work hard for mine.' I could relate to it. So, I realized that I shared something with that little bird. The little brown creeper is not an exciting bird, just steady, just like me!"

At that moment, Hazel understood that her love of the outdoors was shared by her bird-watching friends. She recalls this turning point, "I realized how important the mission of the National Audubon Society is, to protect the environment."

Hazel joined the fight and became secretary of the Seattle chapter of the National Audubon Society the year before she retired from being a legal secretary. It is inspiring to realize that Hazel began her important life's work at age sixty-seven, just when many people would be slowing down. Now she is also a member of several other conservation organizations and has edited the Federation of Western Outdoor Club's magazine for seventeen years. Unquestionably, her steady perseverance of environmental preservation has given Hazel immense satisfaction over the years. At the age of 101, she remains an ardent outdoors woman.

"I like to camp and still go at least once a year. Every Memorial Day Weekend people from all the Audubon chapters in the state—about three hundred people—go to a place that was set aside years ago by Boise Cascade, the lumber company, for their employees. I was involved in getting this land set aside as a nature preserve. After twenty-five years, they gave me a sweatshirt that says, 'Hazel Was Here First.' They named the whole place after me. It's called the Hazel Wolf Wildlife Refuge."

What pleases Hazel as much as having a refuge named after her, is the educational work being done in her honor. "For my hundredth birthday, the Seattle chapter of the National Audubon Society organized a big party as a fund raiser. They raised more than $200,000, which will go for education, to introduce pre-teenagers to the outdoors and to conservation."

Hazel's devotion to education—both learning and teaching—has helped keep her mind sharp. Although she doesn't own a television—she finds it too stressful and a waste of time—she is fully informed on political and social issues and is always prepared to give officials a piece of her mind. She has a

quick wit and peppers her conversations and speeches with jokes, which often cause her to chuckle before her audience does. She's always on the go and travels throughout the U.S. speaking to audiences that range from school-children to government officials.

Although, with her white hair and glasses, she looks very much like a picture-book granny, Hazel doesn't think of herself as old, nor does she worry about how people perceive her. She chuckles at the questions she is frequently asked about aging, assuring her questioners that she has most of her own teeth, eats no special diet, and has no clue to The Secret of long life.

"I'm not doing anything the experts say you're supposed to do. I don't drink six glasses of water daily; I only drink when I'm thirsty. The only exercise I get is running for buses," Hazel says, almost proudly. "Basically, I eat what I want to eat. I eat salt and whole milk. I eat eggs, but fish is too expensive. I quit eating meat because I read a book about how badly they treat the animals. I don't buy junk food—it's too expensive. And I don't buy anything packaged, canned, or frozen because I think something is taken away from food when it goes through those processes. I live on vegetables in season and I steam everything because I hate to cook. For dessert, I usually eat a half a grapefruit. So, for all the wrong reasons, I probably have an ideal diet."

Hazel, circa 1917

Hazel is pleased when people—particularly children—want to know what it is like to be old. With a wink, as if she's about to share something private, Hazel says, "I'll tell you how I feel being old, I feel like Hazel. I felt like Hazel when I was in my nineties. I felt like Hazel in my eighties, and I felt like Hazel in my fifties. As far back as I can remember, I've felt like Hazel. I've always felt like myself."

Clearly, Hazel is totally comfortable being her age, wrinkles and all. "Children fear old age; all younger people do. They see old people and think that they look bad—all wrinkled and gray—and they are afraid of being that way, too, someday. Well, there's nothing to be afraid of.

"I just do different things now. When I was twelve or fourteen, the last

thing I wanted to do was be indoors in school. I wanted to be out swimming and running and climbing. I was very athletic. At that age, the thing that I was most afraid of was getting up and giving a speech to a group of strangers. Now, I love giving speeches," Hazel says laughing, "and I have so much work to do protecting the environment that I rarely have time to be outdoors enjoying it!

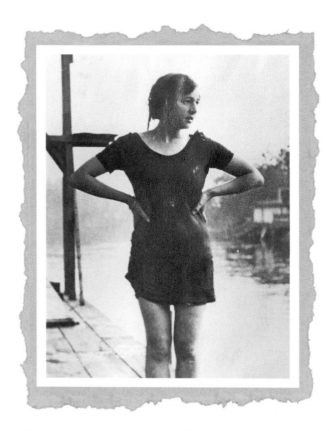

Hazel, circa 1917

"The most important thing is to do what you want to do, and that's different at different times in your life. What you want at fourteen is different from what you want to do when you're ninety or a hundred. But whatever you do, you've got to have fun."

Hazel sighs as she looks around her office. "I guess I am still a radical and I hope I always will be." And she explains, "What I mean by being a radical is somebody that gets to the root of things."

Even a visit to the doctor becomes a cause for Hazel. Unwilling to have health insurance costs deducted from her meager pension, a bout of pneumonia left Hazel with a dilemma. "I heard about a free clinic, so I went down there for treatment. You never saw doctors act the way these guys do, so caring. They call you up to see how you are getting along and even make housecalls," she says. "Sure enough, now I'm on the board. At the board meetings, all we ever talk about is how we can give better service to our patients. We help everybody, including a special division for people with AIDS. For my illness, the clinic pharmacy gave me five pills. When I asked how much they cost, he said, 'Eighty-four dollars, but the manufacturers donate these to us.' So, you find good people all over the place—even where you least expect to find them."

Clearly, Hazel believes in people. She is tolerant and open to new ideas and is always willing to listen to another point-of-view—even one she finds objectionable. She is an iconoclast who delights in challenging people's stereotypes and prejudices.

"I've found that not many people are basically bad. People are different, but that, in itself, is not bad. People have reasons for their beliefs and actions

and these are usually based on how they were treated and what they were taught as children. Most people do what they think is right.

"I've learned a lot of things about life. One of the most important things is to listen to other people—particularly people with whom you disagree—and try to find out how they are thinking. Don't just fly off the handle and say that they're wrong. In other words, respect them. Respect every human being."

It doesn't take much to get Hazel involved. If Hazel learns about a cause she views as just, she readily joins the battle. For example, to appease some friends who were hosting a lecture on Nicaragua, Hazel attended to help them fill the hall. "Nicaragua meant nothing to me," she recalls. But Hazel's interest was aroused when she heard that Nicaraguans were trying to preserve their environment—stopping the use of DDT, banning logging in ancient forests. "I wanted to see what they were doing, so I went with a tourist group all over Nicaragua," Hazel says.

The civil war was still raging there and Hazel observed much suffering. She comments, "I came back from my trip with a determination to get medical supplies for Nicaragua. For my ninetieth birthday, I organized a fund raiser for that cause. We raised $4,500. I went back to Nicaragua five times and made friends there. Eventually, I was asked to be one of the international election observers—along with former President Jimmy Carter."

"If I don't like the way something is, I try to do something to change it. I organize my friends and, in time, others follow."

Hazel makes all her efforts and accomplishments sound easy—as if anyone could follow in her footsteps. Perhaps that's her greatest gift, her ability to inspire. "If I don't like the way something is, I try to do something to change it. I organize my friends and, in time, others follow." As if giving a simple recipe, Hazel explains, "In my organizing efforts, I get people together and tell them what needs to be done, and all the advantages and why it's worthwhile. If they buy it, then it happens. I seem to get all the credit and they do all the work!"

With a perfectly straight face, but a mischievous twinkle in her eyes, Hazel states, "My halo is getting too small, so I'm getting a new one with buttons on the back like a baseball cap—so I can let it out as my head swells!"

Roberta "Bobbie" Green

BORN OCTOBER 26, 1897

Entrepreneur—Born near Little Rock, Arkansas, Bobbie Green
has been a businesswoman, a hotel operator, a TV newswoman,
an interior decorator, and a public relations person.

ONE WORD COMES to mind immediately when describing Bobbie
Green's personality—champagne. Her bubbly disposition is an effer-
vescent celebration of life. She accounts for her optimistic outlook with a
very direct, matter-of-fact explanation: "I am happy because I choose to be,"
she asserts. "I enjoy life, and the Lord has been so good to me. Even though
now I don't see well and I don't hear well, I'm still relatively healthy. I can
choose to be unhappy or happy, and I choose to be happy—and I am."

Even though she now uses a walker, needs hearing aids, and her eyesight
is diminished due to macular degeneration, Bobbie does not view her world
as limited. "You make your own world and your own happiness," she explains
emphatically in her gentle southern drawl. "You can only have one thought
at a time, so you should choose your thoughts carefully. Oftentimes, I visual-
ize beautiful flowers that I've seen previously, and when I visualize them I can
see them just as clearly as I could when I was able to see. And if something
is bothering me, that image puts me in a pleasant mood."

She continues in more depth, "I have a personal relationship with the
Lord, and when I have a challenge or problem, I do what I can to correct it;

and if I cannot take care of it myself, I let go and leave it to God, and he has never failed me yet." She reflects on how her faith has helped her to face old age by saying, "I have less stress in my life at this time than I have ever had in my whole life."

This inner strength has helped her through the deaths of three husbands. She married her first husband, her neighbor Brian Montgomery, in 1917. Bobbie describes him as "one of the most wonderful men ever born."

With the advent of the U.S. entry into the First World War that year, Brian went into the Army.

In the service Brian learned the baking trade, and when he returned home, he and Bobbie moved to Kansas City and opened a bakery. They worked in the business together, Bobbie dealing with the customers and Brian doing the baking. Their venture thrived, thanks to a ready-made pie crust he developed.

While out for a drive, Bobbie met the man who would, much later, become her third husband, Hise Green. "Brian and I passed through Joplin, Missouri, and we stopped at an ice cream shop," she explains. "We really liked the ice cream, so my husband said, 'Let's go upstairs and meet the owner.' He had an office upstairs, and his wife was his secretary. We found that we had a lot in common with this couple. We visited back and forth and were friends with Hise and his wife for many years."

When the Great Depression hit, Bobbie and Brian lost their business. They moved back to Arkansas. "We had purchased ninety acres down near Bella Vista, Arkansas, and we just moved back home." Bobbie recalls that their finances rebounded. "Eventually we built a new business, a motel. And it did quite well. It was very close to the Missouri border and a highway with a lot of traffic. We called it 'Peacock Courts' because we had a lot of live peacocks."

Brian died of a heart attack in the '40s. Bobbie's memory of the exact date is a bit fuzzy. "I've done so many things in my life," she says with a charming southern belle smile, "Sometimes it all seems like a dream."

In 1949 she was married for the second time, to Ray Garvin. He had been a guest at the Peacock Courts and became friends with both Brian and Bobbie. After Brian died, he consoled Bobbie, and their friendship blossomed into a romance.

After their marriage, the couple moved to California to pursue business opportunities. There, Bobbie worked as an interior decorator at the prestigious Bullock's Wilshire department store. She had many well-to-do clients, but remembers one in particular. "Mrs. Harrah, wife of the casino king, came in to buy furniture for their home in Arizona. She described what she

wanted, and she bought everything that I suggested," Bobbie says with an obvious sense of pride in this acknowledgment of her good taste.

While living in California, Ray became ill with leukemia, and the couple decided to return to Arkansas to be near family. After Ray passed away, Bobbie went back to school at Capital City College in Little Rock. In 1971 she was named the outstanding student in radio and television broadcasting. She also worked for the college's public relations department, appearing on local television spotlighting the college. She also appeared in commercials for local businesses.

Meanwhile, Hise Green's wife passed away, and in the process of consoling each other, the long-time friendship between Bobbie and Hise deepened—and Hise became Bobbie's third husband. "I've been fortunate that the Lord has sent me three wonderful men," Bobbie states.

While she trusts the Lord to provide, Bobbie does have some practical advice on romance: "Girls should be very selective. Don't run after any man; let a man run after you. Then, if you're interested, fine; but if not, you can ignore him. That's what worked for me."

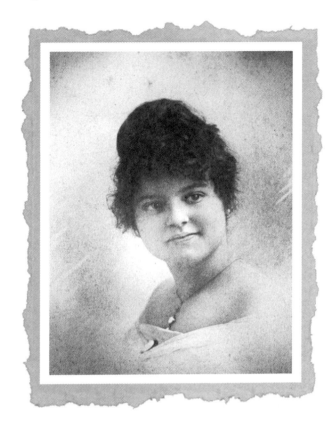

Bobbie, circa 1915

In 1989, Bobbie and Hise moved into the assisted-living facility where she still resides. Ten years older than Bobbie, Hise passed away less than a year after their move.

"I don't feel old," Bobbie asserts. "I go to the hospital every three months for cortisone shots because the cartilage in my knees has worn out. I was just over there and they asked me, 'To what do you owe your longevity?'" With a wink, Bobbie answers, "To the fact that I didn't die."

She continues on a very serious note, "When my time comes, I'm ready for it. I have so many loved ones who have already made it to heaven, and I'm trying to make it there too. I feel that if you live a Christian life, and do unto others as you would have them do unto you, then you cannot lose."

However, always practical and living in the present, Bobbie smiles and says, "I hope I win at Bingo on Saturday night. It will help pay the rent until I get to heaven."

EMMA WRIGHT

BORN NOVEMBER 11, 1899

Family Woman—Born into a farming family in Fresno, California,
Emma's favorite inventions are electric lights and running water. She recalls having to
study by lantern light, pump water, use an outhouse, and walk a mile to school.

To commemorate Emma Wright's one-hundredth birthday, her grand-
daughter presented her with a hand-crafted booklet, "One Hundred
Lessons I Learned from My Grandmother." Emma is proud to see that her
values have been passed from her, through her daughter, to yet another gen-
eration. "Number one on the list is, 'Tell the truth; keep your honor bright,'"
Emma reads. The phrase "honor bright," Emma explains, was the code-word
she used when cross-examining her daughter—the same way some use the
phrase "cross your heart." Emma continues reading the list: "Number two
is, 'If it's not yours, leave it alone.' Number three is the big one: 'Blood is
thicker than water; remember, family comes first.'"

Emma learned the value of family and her other life lessons as the third
of seven children. Her three sisters and three brothers were always her closest
friends. Both younger sisters and a younger brother, all in their nineties, still
are. They grew up on a ranch near Fresno, California, and the old home site
is still family-owned. "I was about three months old when my dad bought a

twenty-acre ranch and we moved out to the country," Emma says. "I lived there until I was married, and that was June 14, 1926. My dad kept adding to the ranch, so by the time I left home he had about sixty acres."

Her father was a German immigrant with a strong work ethic. Everyone pitched in. Emma recalls that she started working—not just doing household chores—when she was about eight years old. "We raised grapes, peaches, and apricots, and some alfalfa and hay. It was the job of all the youngsters to pick and cut the fruit. I mainly cut. Our brothers would pick the apricots and peaches and bring them to a shed, and we girls would cut them. Dad would sulfur them and cure them."

Their father wanted his children to appreciate that hard work had value. Emma explains his method, "My father paid his children at the rate he paid his other workers. For peaches it was five cents a box, and for apricots it was eight cents because they were much smaller. I'm telling you, with peaches it took maybe fifty to fill one box, but with the apricots you needed at least one hundred. At the end of the year, Dad always put what we had earned in the Bank of Italy [now Bank of America, where Emma still has an account] and added a little extra to it. He gave that money to us when each of us got married."

Life in the country was often difficult. Emma recalls walking the proverbial mile each way down a dusty road to school. But if it

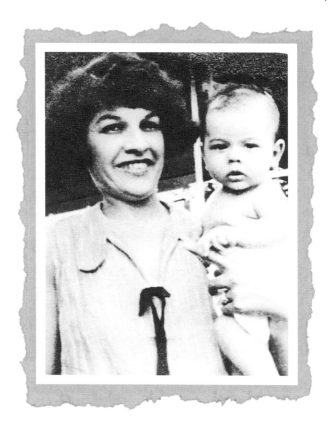

Emma with daughter, Marilyn, 1929

rained, their father took them in the wagon so they wouldn't get muddy. For the family's first decade or more on the ranch, there were no modern conveniences. Emma's two favorite improvements are electricity and running water. "Those are the two best things that ever happened," she states emphatically. "When I was a kid, we had lanterns that used incandescent mantels which made a beautiful white light. Since we were out in the country, it took a little longer for electricity to get out there. I was in my teens when we did get it—I was working already. Gosh, were we glad to get it; it made such a difference.

"Before electricity, every time we needed water, we had to go outside

and pump the water from the well that Dad had dug and bring it in the house in a bucket. When we got electricity, we got a big tank and a little electric pump that would fill it, then the water would be fed into the house by gravity. We still had to heat the water on the woodstove, but it was wonderful just to have it in the house."

After eighth grade, Emma went to work as a sales clerk in a department store in Fresno. By then she got a ride to town in the family's Ford. She enjoyed her job, her independence, and meeting people. Life seemed to be going smoothly as the years passed. Her brother returned home safely from World War I, not even having fought. But 1918 brought a different threat.

"There was a dreadful outbreak of influenza; it was terrible. I was the only one in the family that got sick. I can remember lying in bed just burning up. My father would put cold compresses on my head to try to get the fever to break. My mother had to keep bringing a pan of boiling water so that the steam could help me breathe. At night, the bed felt like it would just go around and around; everything just whirled. The doctor came out every day to check on me. I was sick for more than a month. Afterwards, I was so weak that I couldn't even walk out to the cutting shed, which was only about a quarter of a block away."

"Before electricity, every time we needed water, we had to go outside and pump the water from the well that Dad had dug and bring it in the house in a bucket."

Having survived influenza, Emma had hardly had another sick day until she turned one hundred. Her daughter, and only child, came to take care of Emma and has stayed on with her. But, Emma still does all the cooking and insists that she is taking care of her daughter, Marilyn, not the other way around. Emma walks steadily, without a cane, and can still work in her cherished garden on a limited scale. She drove her car until she was ninety-four. Emma's only complaint about aging is that she has trouble hearing—although she still can hear well enough for phone conversations with her beloved family. She notes that she can't enjoy movies the way she used to when they were silent, "I kind of wish they'd have them now because I can read them better than I can hear them. I go with Marilyn to foreign films now so we can read those." But Emma's real joy is playing bridge, which she does at least five days a week. Marilyn is convinced that this is what has kept her mother's mind completely sharp.

Bridge was also a favorite pastime when Emma's husband, Gilbert, was still alive. The couple was part of an active bridge club and played weekly.

Their social life also included a dancing group, and they went ballroom dancing at least every other week.

Dancing is how Emma and Gilbert met. Emma recalls that first date: "A girl who worked with me asked, 'Would you go out on a blind date?' Her married sister's husband knew Gilbert. Gilbert liked to dance, and they were going to a dance. So, I said yes."

That first date wasn't love at first sight, however. Emma recalls that Gilbert didn't make a good first impression on her. "I was nervous because I thought I couldn't dance very good. And when we were dancing he said, 'You'd be a real good dancer if you'd just loosen up.' Later, when he took me home, he said, 'You live out in the sticks, don't ya.' He lived in town, and I lived six miles out in the country. So, I said to my mother, 'I'm not going out with him again.'

"About a year later, he asked my friend, 'Why doesn't Emma speak to me when I see her on the street?' Well, he always wore a hat when he was out; and the only time I'd seen him, he was without a hat. I honestly didn't recognize him. So, then he stopped me at noon and asked me to go to a dance. From then on, we went together."

Emma also had another suitor, who was studying dentistry in Los Angeles. They wrote letters and she visited—always chaperoned, Emma is quick to point out. But Gilbert won Emma over, and they were married a few months before their twenty-seventh birth-days—he was just twelve days younger than she. Emma laughs as she recalls, "My youngest brother kidded me a lot about marrying so late. 'You're going to be an old maid,' he'd warn."

Emma with husband, Gilbert, 1943

After her marriage, Emma became a full-time homemaker. Her daughter was born in March 1929. Emma and Gilbert were married slightly more than fifty years when he passed away at age seventy-seven. "I was ready to go when my husband passed away," Emma sighs. "I thought maybe I'd have another year or two, not twenty-three. God only knows, I don't know, why I've lived so long. Having the youngsters around, my grandchildren and

great-grandchildren, keeps me going—and always having something to look forward to." Indeed, one of those one hundred lessons noted by her granddaughter is: "Keep looking forward."

True to her principal rule of family being primary, Emma recalls, "Having my daughter was the happiest day of my life. Some people would say their wedding day, but I was so nervous about having to go to bed together. I didn't know what the folks know today."

The last two guidelines on the list of lessons learned are "Beauty is ageless" and "The world has been created perfect-

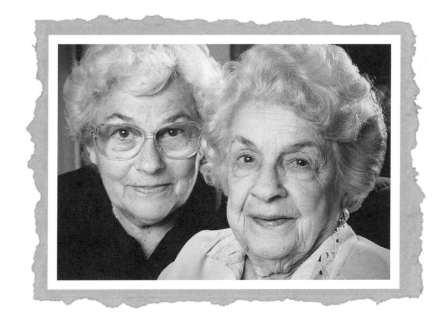

Emma with daughter, Marilyn, 1999

ly; find your place in it." Emma Wright has mastered both. She has found her place as a daughter, sister, wife, mother, and grandmother—a place as part of a family. And this has given her an inner beauty that shines through, honor bright.

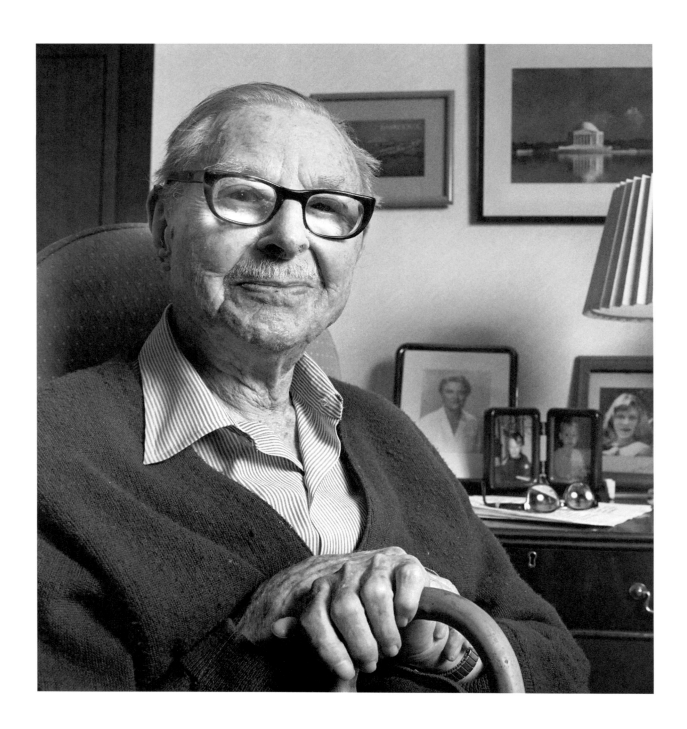

THEODORE J. YOUNG

BORN JULY 17, 1896

*Architect—Born in New York City, Theodore was raised in Canada,
where he studied architecture. He specialized in public buildings.
His best known projects include the Jefferson Memorial and
the National Gallery of Art in Washington, D.C.*

PRECISE. BALANCED. ELEGANT. The descriptions fit Theodore Young and his buildings.

Theodore—Ted to friends and family—created very elegant public and private spaces. During his fifty-eight-year career as an architect, Ted's projects in Washington, D.C., included the Jefferson Memorial, the National Gallery of Art, and the National Archives Building, which houses the *Declaration of Independence* and the *Constitution of the United States.* In London he worked on the Duveen Gallery of the British Museum, which houses the Elgin Marbles from the Parthenon, and the Sculpture Gallery of the Tate Gallery. He also designed numerous churches and university buildings across the United States. Toward the end of his career, Ted was a design consultant for the Throgs Neck Bridge, between the Bronx and Long Island.

His mien is dignified, understated. His voice is modulated, each word carefully chosen and enunciated. With none of the quivering or gravelly texture that often accompanies advanced years, Ted extemporizes as if narrating

a program on public television about the great public buildings of the twentieth century—which he helped to build.

"I am grateful for a long professional career, which progressed with more than an ordinary amount of good luck. I am, with all modesty, respectful of the amount of buildings I have been privileged to plan." Ted is almost self-effacing, but he admits, "I am very proud, proud that people are admiring these buildings and spaces. Certainly the Duveen Gallery in the British Museum is a very handsome room, and I couldn't possibly go into it without feeling pride."

Ted was encouraged to pursue architecture by his father, George, a printer, lithographer, and engraver in Toronto, Canada, where Ted was raised. "My father was a very quiet man, hard-working." Ted could be describing himself as well. He explains how his father came to be entranced with architecture. "Stationery in those days had an engraving of a building—the company's office or plant. My father would get a photograph of the building and engrave the picture of this building on the stone, which he would then print on the stationery. He would bring these stones home and work far into the night using a magnifying glass. As he worked on these buildings, he became determined that I was going to be an architect because he was so impressed with these buildings. He encouraged me and I made no resistance, because I, too, was interested. I planned to go to the University of Toronto and I just directed my scholastic efforts to the department of architecture there.

"In the autumn of 1914, having just turned eighteen years of age, I entered the architectural school of the University of Toronto. Just a month prior to this, England had declared war on Germany." These events changed Ted's course. He enlisted as a gunner in the Canadian Field Artillery, but had an opportunity to transfer to the British Royal Flying Corp (which became the Royal Air Force after the war) and participate in a newly created arena. "I had never flown, but by joining this organization, I was able to learn flying. It was a bit scary, but flying was very new at the time and it wasn't something everybody did. I thought that if you had to go to the armed services, what was the better thing to do? Be a pilot.

"The planes were probably even smaller than you imagine," Ted laughs. "These planes were constructed mostly of wood. The wings were wood with canvas stretched over, with wires to make everything taut. I'm appalled when I think back on how flimsy the air planes were, but they were very efficient. They had an approximate speed of ninety miles per hour. The ones that I flew were used for the scout planes and had to go fast and be very maneuverable."

Ted became a flight instructor and a scout. Ted's calm demeanor gives no hint of the daring missions he once flew. "The artillery was firing on the Germans. We would go up in a plane and watch the direction where they were firing, then report by radio what was going on—how effective, are they going too far, too short, and so on." Despite all his flying experience, after the war Ted never piloted a plane again, although he traveled by plane frequently, both for business and leisure.

As soon as the war ended, Ted returned to his studies. He graduated in 1921 and went to work for an architecture firm in Toronto. In 1923, he decided to move to Chicago because an economic depression in Canada was negatively affecting the building industry. In Chicago, Ted worked for the firm of Holabird & Root, which concentrated on building hotels.

But, his most rewarding experience during this time—both professionally and personally— was a class he decided take. "I enrolled in an architectural and fine arts school, in a place called Fontainebleau, just outside of Paris, France. The course was for the whole summer of 1924, after which I toured France, Italy, and Switzerland, returning to the office in January of 1925. My instruction over there was beaux arts training." This would serve Ted well in his future work on grand public projects.

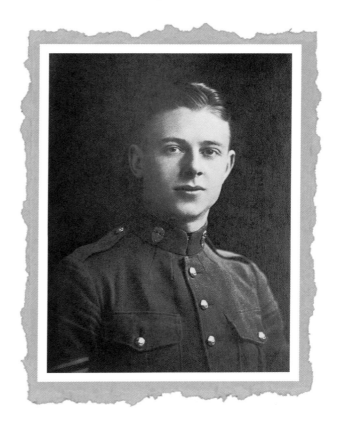

Theodore, British Royal Air Force, 1915

"The firm gave me a very important project to do while I was in France," As Ted recalls even this early assignment, his love of the design process is evident in the excitement in his voice. "They were building a very large hotel in Chicago and wanted to do all the electrical work in French-style lighting fixtures, which they could buy beautifully made in Paris cheaper than they could in the United States. They gave me the commission to take plans of this hotel to several firms in Paris, have them looked over, and obtain bids on making the fixtures."

The trip to Paris had a personal effect on Ted, too. "Fontainebleau, where I was studying, is a big palace that the government turned over to be an art school, and that's where I met my wife, Janet. She was studying painting. There were a lot of girls there, but I was particularly interested in what she was doing. I used to pause and see what she was doing every day. So that's

how we got acquainted." Janet happened to be an American from the New York City area. Although Ted and Janet parted at the end of that summer, they courted through correspondence, and a plan soon developed that Ted would seek employment in New York and they would marry.

In October 1925, armed with a letter of introduction, Ted moved to New York City and was fortunate to gain employment at one of the foremost firms in the U.S., the office of John Russell Pope, which specialized in the design of public buildings. Ted became a partner in the firm after the death of Pope in 1937, and worked there until he retired in 1979 at the age of eighty-three.

With Ted's career secure, he and Janet married. They lived in Brooklyn Heights, and Ted fondly remembers walking to work daily across the Brooklyn Bridge. Walking became a lifelong habit. Even after he and Janet moved to suburban Connecticut, Ted continued to walk several miles a day—a practice that has most likely contributed to his longevity.

Theodore with daughter, Jane, date unknown

The couple were married more than sixty years when Janet passed away in 1989. They raised a son, George, and daughter, Jane—who followed in her mother's footsteps as a painter. Both grandchildren are also artistic in their own fields—Ian as a chef and Jessica in the movie industry. Ted suspects that his two great grandchildren will also have creative talents.

In the course of his career, Ted worked with luminaries, including Andrew Mellon, in designing the National Archives beginning in 1930 and later the National Gallery of Art; John D. Rockefeller, Jr., in designing the Frick Collection museum from 1933–1935; in collaboration with Francis Cardinal Spellman on dozens of buildings built for the Archdiocese of New York; and Dwight D. Eisenhower on renovation of the presidential residence at Columbia University. Ted also worked on numerous university buildings, including more than two dozen at Indiana University alone, numerous hospitals, office buildings, and a select number of private homes.

Perhaps his favorite collaborations, beginning in 1930, were the Duveen

Gallery of the British Museum and the Sculpture Gallery of the Tate Gallery. "I particularly enjoyed working with Lord Joseph Duveen," Ted says of the patron of these two projects. "He was an extraordinary art dealer who had made a fortune as purveyor of great art masterpieces to a group of eager American millionaires vying with each other in assembling collections. He influenced the collections of Rockefeller, Morgan, Mellon, Frick, and many others. At the same time, he was shaping American taste in art. He also gave away large sums of money to art institutions. Working together, we became close friends and he performed many kindly acts for my benefit."

The commute to London was also a benefit of these projects. "This was before the development of popular air travel, and the trip by ship took about ten days." As Ted describes it, this was more of a vacation than a business trip. "The fastest ship was *The France,* a French ship which was very, very luxurious. It was lovely. I enjoyed every minute. The cabins were comfortable—much more comfortable than going by plane. The activities on the ship are interesting, and you have nice dining and living quarters. It's a lovely way to travel." Once in England, Ted would stay for a month or so to supervise the projects.

A less luxurious commute by train to Washington, D.C., resulted in probably the best known of his projects, the Jefferson Memorial. The project had many stops and starts due to political and funding considerations, but finally got underway in 1934. "John Pope decided that we should have a building that Jefferson would have admired," Ted explains. "Jefferson admired the dome architecture of the old Romans. And what we did was very much like the architecture that Jefferson did at the University of Virginia and at his house, Monticello.

"I was there when President Roosevelt laid the cornerstone and still later when he dedicated it on April 13, 1943, the 200th anniversary of Jefferson's birth," Ted says.

"One of the most interesting untold stories of the Jefferson Memorial is when President Roosevelt approved the plans. A very fine drawing was made of the preliminary design, and it was decided that I should take it and show it to Mr. Roosevelt in the White House.

"There was a senator, a congressman, and myself who were picked to go show the drawings. We were ushered into the Oval Office, and it was like all the pictures you've seen so many times of him sitting at his desk with the big

"I was there when President Roosevelt laid the cornerstone and still later when he dedicated it on April 13, 1943, the 200th anniversary of Jefferson's birth."

windows. So we took those drawings in, and he opened them carefully and made some comments. Then he said, 'Will I be able to turn in my chair and look out and see this building?' And the congressman said, 'Mr. President, there are so many trees, we doubt very much that you'll be able to see as well as you think you might.' So the President said, 'Don't give that another thought.'

"It wasn't known for many years that he had a discussion with his good friend in the National Capital Parks and Planning Commission—and the trees that were such a block to this vista began disappearing. Every night the President had his friend cut down one tree until the trees had been thinned and there was a clear vista. There never was any notice in the newspapers or any scandal; this was just something that seemed to evolve. I was always astounded that nothing was ever said about the removal of those trees!" Ted remarks, shaking his head knowingly at the workings of politics.

Perhaps one of the reasons Ted has been so successful in completing public buildings is his even temperament, which helped him get through the stresses of politics. Just as he strives for balance in his designs, so does he also in his life, practicing yoga in addition to his daily walks, and practicing mental discipline.

Ted's advice for success is based on discipline. "Hard work is the best key to success. You have to be steadfast, stick with it." He expands this further: "You should not focus your attentions on your limitations—either internal, psychological blocks or external factors—because that makes them worse, more limiting. To excel, you must transcend your boundaries. You must think positively and know that what looks like a problem or obstacle can be turned into an advantage. Then, at the end of the day you will be able to say that the weather was fine—rain or shine."

Acknowledgments

Tʜɪs ᴘʀᴏᴊᴇᴄᴛ ᴡᴏᴜʟᴅ not have been possible without the support of all the centenarians and their families, friends, and associates. Thank you all for sharing your lives with me and honoring us with your stories and insights. Special thanks to Irene Gastelum and Roger Harris for introducing me to some remarkable centenarians.

Thanks for behind the scenes support goes to Lauren Skellen, Brenda Dawson, and Rita Rosenkranz. I am grateful to my entire team at Prima Publishing for making this project possible. Working with all of you has been wonderful. Also, a big thanks to the team at Golden Turtle Press who published the calendar, *Reflections on a Century,* which led to this book.

Thanks to the guys at The Darkroom in Mountain View, California, for their expert film processing and technical consults.

Special thanks to my parents, Ben and Betti Kruse, for their encouragement and for their enthusiasm—and for their suggestions of parents of their contemporaries for inclusion in this book. Thanks to my brother and sister-in-law, Steve and Penny Kruse, for help with research.

And I am grateful to my grandparents, Saul and Frances Frank and Anna and Alex Kruse—who, if they were living, I would have joyfully included in this project—for the memories which they shared that have inspired me to do this project.

My husband, Richard, was a continuing source of logistical and computer support. No project I do could succeed without him.